IMAGES
of America

MEXICAN AMERICANS
IN REDLANDS

To fer Opdryke

ON THE COVER: Citrus is being packed at Pepper's Packing House in the 1940s. (Courtesy Nellie Del Rio.)

IMAGES
of America

MEXICAN AMERICANS IN REDLANDS

Antonio Gonzalez Vasquez
and Genevieve Carpio

ARCADIA
PUBLISHING

Copyright © 2012 by Antonio Gonzalez Vasquez and Genevieve Carpio
ISBN 978-0-7385-9522-1

Published by Arcadia Publishing
Charleston, South Carolina

Printed in the United States of America

Library of Congress Control Number: 2012934478

For all general information, please contact Arcadia Publishing:
Telephone 843-853-2070
Fax 843-853-0044
E-mail sales@arcadiapublishing.com
For customer service and orders:
Toll-Free 1-888-313-2665

Visit us on the Internet at www.arcadiapublishing.com

*For Rafael V. Gonzalez, Blas Coyazo, and Leland
Richardson, gentlemen one and all.
And to the elders who shared memories for us to carry forward.*

CONTENTS

ACKNOWLEDGMENTS

In the early 1990s, I was approached by Dr. Larry Burgess, director of A.K. Smiley Public Library, with the idea of interviewing citrus workers about their experiences working in Redlands, the self-proclaimed "Citrus Capital of the World."

The project that developed became more than a discussion of work in the groves and packinghouses. While citrus cultivation and citrus labor played a role in the conversations, I tried to learn more about what makes a community. The interviews that are part of this book attempt to put lifetimes of experience in images and words which, though only temporary, are ultimately all we have to draw from. To Gena, you are an amazing inspiration and the driving force behind this book, may your life be long, eventful, and always fulfilling.

I am forever grateful to Kathleen Case for bearing our children Calli and Maz, nurturing my vision, providing outstanding transcription, and helping to create the original exhibits from which this book derives.

Special thanks to photographer Will Chesser, who volunteered his time to photograph events. As our photographer-at-large, he developed an amazing portfolio. We are proud to present his images, many of which have never been published. Thanks to Maxwell A. Ronning, Sean Redar, Janice Jones, Miriam and Neil Case, the California Council for the Humanities, Professors Jim Sandos and Leela Madhavarau at the University of Redlands, Community Presbyterian Church, American Legion Post 650, Kezia Merwin, Lancer Graphics, *Press-Enterprise* newspaper, *Redlands Daily Facts*, *La Prensa*, John Pfau Library at Cal State San Bernardino, San Bernardino County Central Library, Sandy Mishodek and Dr. John Massey at Clement Middle School, Graciano Gomez and Inland Counties Hispanic Roundtable, Gerald Lawson, Jon Hughes, Daniel K. and Laura Case, Dr. Alec Ormsby, Dr. Anthea Hartig, and Dr. Ward McAfee. Genevieve would like to thank Eric Gonzalez and Vince and Connie Carpio for all their love and support.

Unless otherwise noted, all photographs and documents are courtesy of Inland Mexican Heritage. We are deeply grateful to all of those who provided images.

Lee Richardson probably holds the record for participation in this work. He was interviewed both on tape and video, he appeared at more events than anyone except the authors, and he donated many photographs to the collection. I met Lee through his baby sister Rita Richardson Radeleff who was known to the family as "Millie." Rita passed on shortly after her 75th birthday, but Lee and I were able to continue our friendship until he passed away just a few days short of his 90th birthday. From the moment we met, Lee encouraged me to write a book about "the working people of Redlands" and never stopped supporting our efforts. Our last visit with Lee was at his home to film for *Living on the Dime*.

Finally, to my mother, Eunice Romero Gonzales (1923–2007), whose connections, translations, and deep knowledge of the community made this all possible, may you be forever at peace.

THE LINE
by Robert A. Gonzalez

I.

We live in a world of lines.
Lines can bring us together and lines can keep us apart.
Lines can take us places or keep us in place.
Lines can uplift us or bring us down.
This story is about a small town where not so long ago, in a place not so different from anywhere else
the lines were not always the same for those of us whose skin was darker than others.

II.

People have always migrated, moved from place to place.
We seek new ideas, different opportunities, another way of life.
When our grandparents were children the border was just another line that people could cross
 for a few pennies at a time.
We traveled by train, boat, and often on foot to find what we were looking for.
From all across Mexico we came.
To Texas, New Mexico, Arizona, California and on to points north.
With strong backs and willing arms we came, some working the railroad, others following
 crops, and all for the very reasons this country was born— freedom, opportunity and
 dreams of a better life somewhere along the line.

III.

We worked together to build those monuments to culture and prosperity so important to the life
 of a town.
We worked our jobs, we made our homes and we represented ourselves with pride and dignity to
this nation on the factory lines and on the front lines for freedoms still to be won.
Lines are never still or permanent, they move and change, merging and separating, crossing
 and traveling
 together.
Every day we leave behind but never really lose the past, we can only try to expand our ability to
 understand with compassion and thought the lines that shape our lives and our time.

INTRODUCTION

The lure of California's golden promise called rich and poor, healthy and ill—people of all colors and creeds. From Ellis Island to Angel Island, the United States has long mythologized the arrival of immigrants seeking opportunity, adventure, and the unknown across the nation. However, no such monuments exist for the indigenous peoples of the American continent for whom migration was defined by movement between, across, and within the later-defined lines that separated cities, states, and nations. The common pursuit of opportunity through migration left some with the honorific title "pioneer" and others with the status "illegal immigrant." Somewhere along the way, the line separated more than land; it separated people. Yet they continued to migrate in the pursuit of better lives for themselves and their families, even if it meant crossing the line.

The City of Redlands was incorporated in 1888. From its earliest years, it was celebrated as one of the wealthiest and most picturesque cities in the San Bernardino Valley. Nestled at the foot of the San Bernardino Mountains, Redlands was a center of the citrus industry that was the economic lifeblood of inland Southern California. By 1903, the young city shipped 2,500 carloads of citrus a year, operated 15 packinghouses, and was the site of A.K. Smiley Library, as well as a variety of cultural landmarks. Redlands was described as the "Pasadena of San Bernardino County," the "City of Millionaires," and one of the "garden spot[s] of the world."

The Mexican American communities of Redlands and the east San Bernardino Valley continue to be a vital part of Southern California's history, but for many people, the stories and images of the barrios that shaped the Mexican experience have been lost due to neglect and the passage of time. For most of the modern history of inland Southern California, people of Mexican descent have comprised the largest non-European ethnic population, yet very limited photographic and documentary materials on this group were available to the public or for research purposes.

From 1994 through 1997, third-generation Redlands native Robert A. Gonzalez recorded life stories of elders from among the Mexican communities of the east San Bernardino Valley. With the support of A.K. Smiley Public Library, 30 interviews were recorded and 22 transcripts were published as *Citrus, Labor and Community*, housed at Smiley's Heritage Room Archive.

After the transcripts were published in 1997, there was considerable public interest in developing a photographic and oral history documentary project to expand upon the original interviews. Under the name Redlands Oral History Project, a collection began to take shape. By documenting and sharing the history of vibrant Mexican communities throughout the east San Bernardino Valley, it challenged prevailing stereotypes of Mexican American cultural, social, and economic life in the region.

In 2001, Gonzalez founded Inland Mexican Heritage to continue promoting cultural and historical research throughout Southern California. It was at this time, as a student, that Genevieve Carpio became involved with the organization, and she has maintained a vital role as a research consultant for Inland Mexican Heritage in the years since.

The images and text in this volume represent a distinct departure from most historical photograph books. Photographs were collected primarily from the people who took them or knew the people in the images personally. By combining images and interview excerpts, the stories within these pages offer something unique, something that even the most knowledgeable historian cannot provide: a community story told from the perspective of the people who built it.

One

BORDERLINES

War and social unrest are often cause for migrations but rarely the only compelling reason for families and individuals to make the often difficult journey from one country to another. While many people did take refuge in the United States during the early-20th-century conflict known as the Mexican Revolution (1910–1917), many more people from Mexico had long-standing ties to California that predate this period.

Mexicans had established settlements locally at Agua Mansa and in the sprawling railroad barrios of west San Bernardino and south Colton, and they were present at the founding of nearly every community in the area since. As people from all over Mexico settled in the region to work and build homes and lives, they brought with them a sense of pride in both their old country and their new, as well as a mingling of social and cultural traditions from both places. Mexicans and Mexican Americans were among the earliest migrants to call the city of Redlands home, laying the foundation for generations to follow.

Many arrived by horse and cart, some on foot, and the most fortunate aboard the steam locomotive. For all, the site of the Santa Fe Depot marked the end of a long journey. People of Mexican descent settled near the tracks, where land was affordable and community life was rich. They built homes and churches, organized theater and musical groups, grew Victory Gardens during World War II, raised children who attended local schools, planned return visits to Mexico, wrote letters encouraging loved ones to visit, and created a community with a deep history that endures to this day.

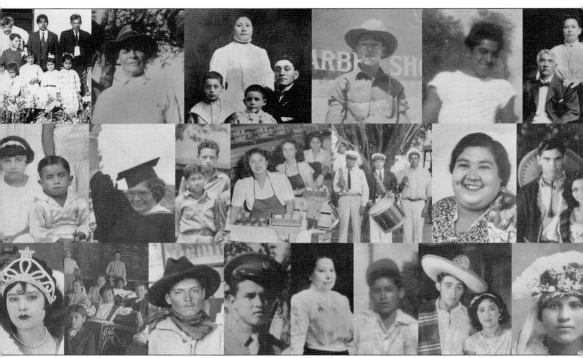

Inland Mexican Heritage currently holds an archive containing hundreds of photographs, over 150 hours of audio and video interviews, primary documents, and other materials that preserve stories of the Mexican experience in Riverside and San Bernardino Counties.

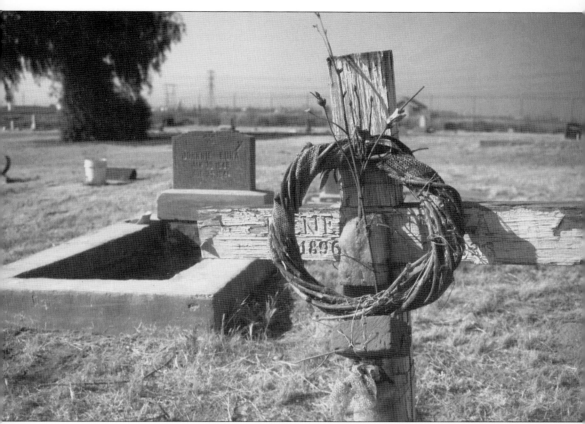

This historic cemetery is located in Agua Mansa, the earliest Mexican settlement in the San Bernardino Valley. The Federico family, pictured on page 12, lived in Agua Mansa before relocating to Redlands. In her unpublished memoir, Mercedes Federico's granddaughter Rita Radeleff wrote: "Quintin Velarde and Mercedes Federico Velarde came to Redlands and made their home here about 1892. Their one and only child was Tomasita Edith Velarde, who became my mother. Mom was an only child and she married at the age of 17 or 18 to a Mateo Guzman, one of six brothers who were born in Los Angeles. She and Mateo were married for about three years when he died. My brother, half-brother, Matthew Moses Guzman was born July 13, 1911, about 10 days after his father died." Tomasita Velarde is also noteworthy as one of the first Mexican women to become a nurse in early Redlands. (Photograph by Will Chesser.)

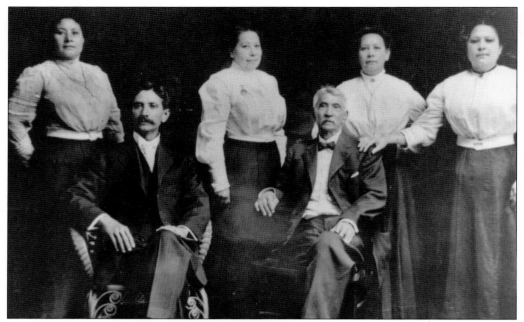

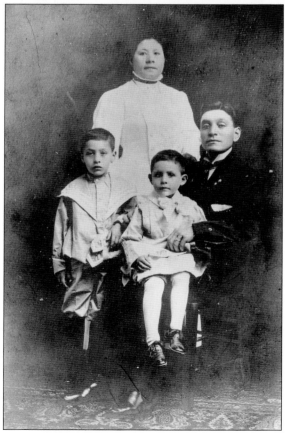

The Federicos are pictured in Redlands in 1895. From left to right above are (first row) Alejito and his father, Alejo; (second row) Alejo's daughters Jesusita, Mariana, Mercedes, and Eleanor. Pictured at left in 1915 are Epimenio and Jesusita Guzman with their children Carlos (seated) and Richard. The Guzman family settled in Redlands before it was founded in 1888. Jesusita Guzman and Mercedes Velarde were sisters from the Federico family. (Above, courtesy Rita R. Radeleff; left, courtesy Connie McFarland.)

Pictured at right is a typical US entry visa. This one was issued to Emiliano Beas, grandfather of Nellie Del Rio, a prominent member of the north Redlands community. Beas worked many jobs, including stunt work in Hollywood. He settled in Redlands but often returned to Mexico. During the immigration scares of the 1920s, fears that rising tides of dark-skinned foreigners would dilute the American stock made front-page news. Organizations like the California Development Association, purporting to understand the "Mexican problem," often made broad-based, specious, and racist assertions. In one report, dated 1929, it wrote, "There is little evidence, anywhere in rural California of a Mexican disposition to acquire land and make permanent settlement. There is no large body of Mexicans on the soil as citizens and land holders such as solid units of Europeans in the northern Middle West." In response to such reports, the Redlands Chamber of Commerce Survey on Immigration Reform replied in 1929, "We have between 139 and 170 Mexican families who are here all of the time. The Mexicans are trying to buy their own homes and to beautify them with flowers and gardens. They want permanent work; they do not want to become 'floaters.'" Pictured below, from left to right, are Nellie Del Rio's maternal family, Julia, Luz, Antonia, and Inez Alvaraz, in front of their home on High Avenue. (Both, courtesy Nellie Del Rio.)

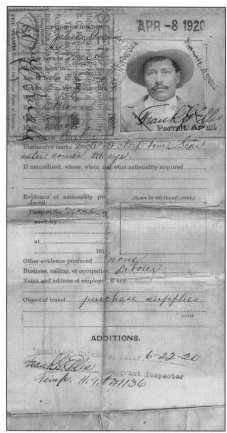

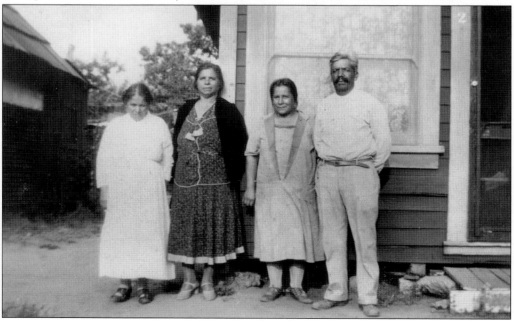

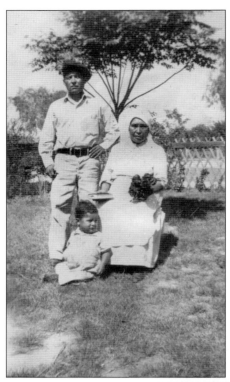

Ygenio and Dorotea Roque, the grandparents of Angelina Sumaya Cosme, are pictured at left. Cosme discussed her family: "I believe my dad was born in Arizona. He was mostly Indian, American Indian. My mother was born in Aguascalientes, Mexico. [She] came to Redlands when she was in her teens . . . [her family] came to this country originally during the Revolution. They would take them to work in the railroads, like when the Chinese were brought here. So, they came here in 1923 and they never left again. My grandmother had two sisters. One of them married another Roque, and she and her husband came to live here in town also. The other sister did not marry, and they had a brother, also. During the Revolution, my grandmother's brother went on an errand or came to the United States, and they never heard from him again." (Left, courtesy Margaret R. Castro; below, courtesy Sam Coyazo Jr.)

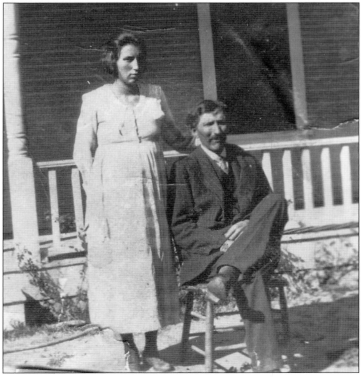

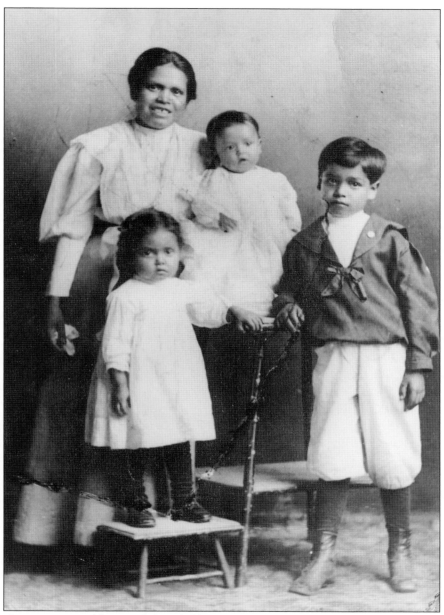

Santos Coyazo, pictured here with her children Consuelo, Sam, and infant Blas in 1911, walked pregnant with her husband, Dionicio, and two children to come to the United States. Over 80 years later, Blas recalled, "My parents came from Mexico, from the state of Zacatecas. It's a mining city, and my dad used to work there when he was a young man. That would be around the turn of the century. Things were getting tough for them, and they wanted to come to the United States to better themselves. So, they decided, my mother and my dad and one son and one daughter, to come to the United States. They came from Zacatecas all the way to Juarez in the state of Chihuahua and to El Paso. In those years, people would pay a certain amount, which was not too much, to cross the boundary from one nation to the other. So from there we came to Redlands in 1910, and I was born the following year, 1911." (Courtesy Blas Coyazo.)

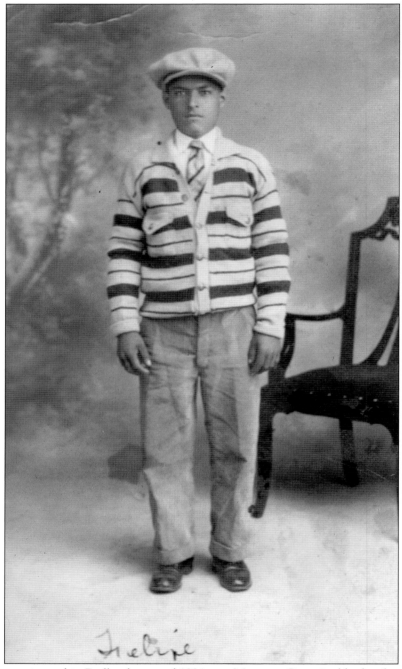

Felipe Roque, pictured in Redlands around 1924, was Margaret Castro's older brother. Margaret related the story of her father, Ygenio, and her family's journey to Redlands: "My dad and some of his brothers went to work in Kansas, and then they came after the families. But, my mother didn't like Kansas. She said it was too cold. There was too much snow and she missed her tortillas and her *queso* from Mexico, so they went back to Mexico." (Courtesy Margaret R. Castro.)

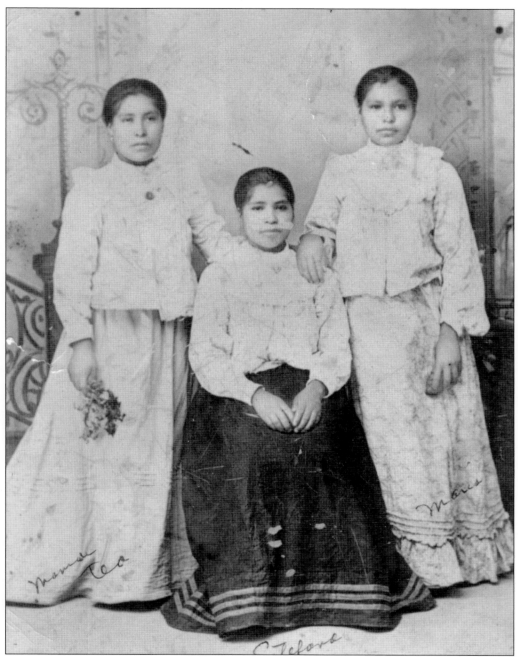

Margaret Castro continued, "They were there in Mexico for three years, and it was harder and harder for my dad to make a living to support his family. My mother already had a sister named Gavena Roque here in Redlands. So my father would say, 'Okay, we're going back, but this time we're going to California with my compadre Asuncion,' his brother-in-law. That's how we ended up in Redlands, following my mother's other sister and her family." Castro's mother, Dorotea, is pictured on the left with her sisters Estefana (center) and Maria in Aguascalientes, Mexico. (Courtesy Margaret R. Castro.)

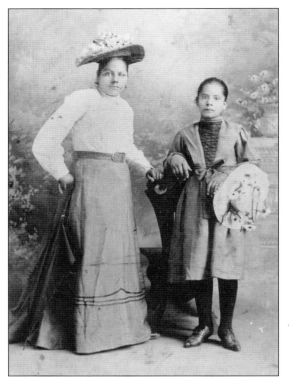

These Roque family pictures were taken in Aguascalientes. In the early 20th century, Mexican American women had limited options in the workplace but would serve the community through churches, mutual aid, and relief organizations, such as the Cruz Azul and Progresista de Feminil. Lupe Roque Yglesias recalled: "All of us Mexicans had little jobs. Like, I worked cleaning houses; I worked at the laundry, packinghouse, then I retired from Loma Linda as a housekeeper. Yeah, Mexican people were supposed to not have no education, so you start labor. Now, we have a niece that has a Ph.D. We've come a long way." (Both, courtesy Margaret R. Castro.)

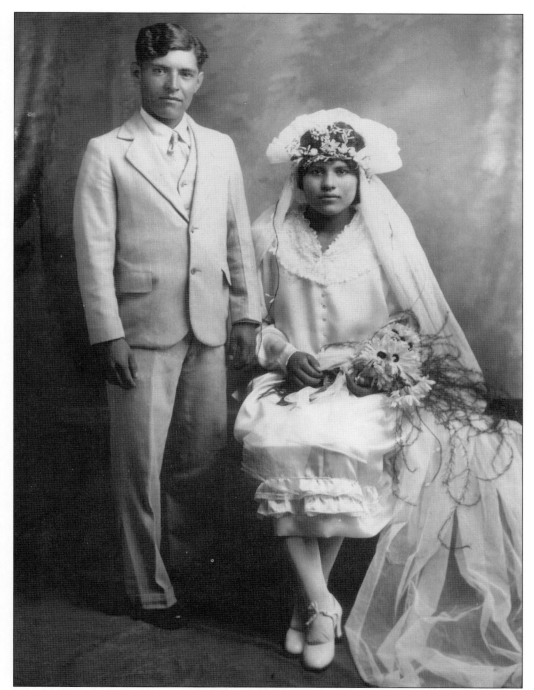

Many families solidified their connection to the community through marriage. Couples would often settle on the same block and, generally, in the same neighborhoods as their extended families. This helped provide a support system that served a variety of purposes from aiding in childcare to maintaining social ties. Felipe Roque and his bride, Bicenta, are pictured in the 1920s. (Courtesy Margaret Roque Castro.)

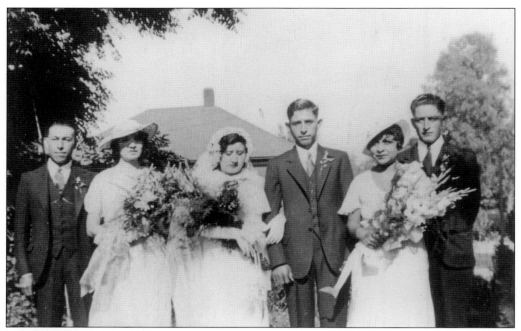

Carlos and Tillie Rodriguez Guzman were married in 1935. Carlos's father was Epimenio Guzman. Epimenio, a blacksmith and musician who came with his brothers from Los Angeles in 1885 to pursue his trade, was among the first Mexican Americans to call Redlands home. Carlos went on to a career with the City of Redlands. Richard Guzman and Guadalupe Jaime are pictured at left on their wedding day in the late 1920s. Richard was employed by Carlson's Hardware on Orange Street until his retirement. (Above, courtesy Connie McFarland; left, courtesy Sandra M. Medina.)

To Mom
From Carlos

The Guzman family home was located on Stuart Street in Redlands. Connie Guzman McFarland recalled, "My grandmother [Jesusita] was born in Magdalena, Mexico. That's where they have the coffin of San Francisco Javier. . . . When she came over, she was a little girl, she brought a sapling of a tree. And that tree, they planted it in front of their house. I think I have the picture of that. And that's why my mom and dad had this type of tree. In fact, those trees are planted, would you believe, at what they call the Catholic Hill at Hillside Cemetery." (Courtesy Connie McFarland.)

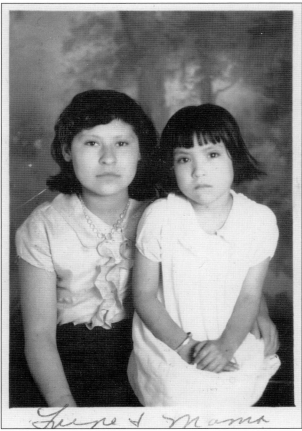

Lupe + Mama

Above, Angelina Sumaya Cosme is seated at center in front of her home in the neighborhood known as "Barrio Judeo." Her aunt, Margaret Roque Castro, pictured at left with her older sister, Guadalupe, described the neighborhood: "I was born in a little area right there on Herald Street, they used to call it El Barrio Judeo, because it belonged to some Jewish people. There were several houses and it was a dirt road going around and on the sides were houses, little old houses, but they were, you know, livable. Then my parents bought that house on Herald Street, 1113 Herald Street. You know, the same street, but farther down." (Both, courtesy Margaret R. Castro.)

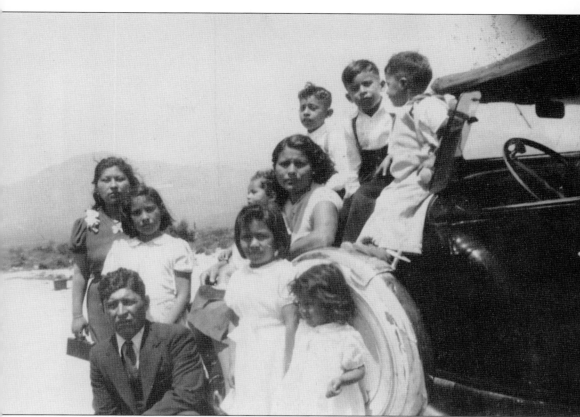

The Roque children, including Felipe and his wife, Bicenta (center, holding baby), are pictured in Redlands during the early 1930s. Lupe Roque Yglesias remembered: "We came into Redlands when I was about two and a half. We lived there in Third Street then we moved into the Barrio Judeo, that area, right there on Herald Street, was the Barrio de Judeo. We had little bungalows, all on that big lot. I was eight years old when we bought the house where we grew up [1113 Herald Street]. We moved into it for $1,000. And the house is still there." (Courtesy Margaret R. Castro.)

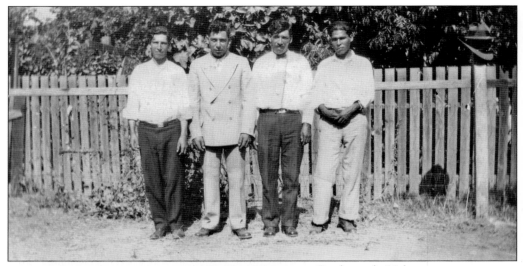

By the early 20th century, many Mexican families had settled and established roots in Redlands. The Mexican *colonia* where most of the residents lived was located north of Highway 99, which is now known as Redlands Boulevard. However, many families lived throughout the city in enclaves close to their jobs. Manuel Jacques, second from left wearing a suit, stands with his brothers in front of their home near the highway on State Street. (Courtesy Mary Garcia.)

Nellie Rodriguez stands in front of her family home on High Avenue in the 1920s. (Courtesy Nellie Del Rio.)

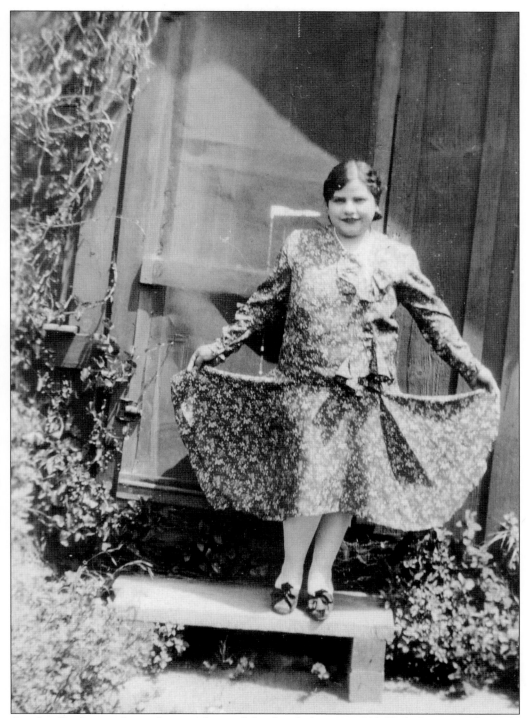

Amelia Cordero is shown here in front of the family home at 305 High Street in the early 1930s. Nellie Del Rio, never interviewed on tape, is a relative of the Corderos. (Courtesy Nellie Del Rio.)

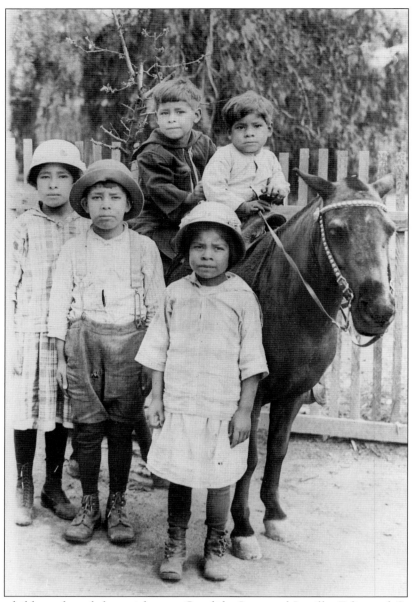

The Ruiz children, from left to right, are Candida, Jose, and Lucille. Felix and Octavio are seated on Catota the mule. Their parents, Augustin and Angela, lived at 509 Lawton Street. Helen Cabral, Augustin and Angela's granddaughter, recalled that her grandfather "came from Zacualco, Jalisco and was born in 1890. He worked on the railroad in Arizona, then homesteaded in Redlands when he was 18. Augustin was a mason who made pipes for irrigating the groves, and he picked oranges seasonally. Catota was used as transportation and for taking the family to Chino to pick walnuts. He was a strong mule. Catota became so recognized that people thought my grandfather's name was Catota, and they called the family the Catota Clan." This photograph was taken in front of their home in 1920. One of Augustin and Angela Ruiz's younger daughters, Aurelia (not pictured), was among the first elders to be interviewed for the Redlands Oral History project. (Courtesy Helen Cabral.)

According to Aurelia Ruiz Reyes, "My grandpa was working, he was here already working in San Francisco at the time of the earthquake in 1906. He went back to Mexico and he brought my dad [Augustin Ruiz] over here to work. My grandpa had some relatives in Yucaipa and they stopped there for, I don't remember, not too long, because they were on their way to San Francisco. They were hitchhiking, and this man gave them a ride up to El Monte. So, the man gave them a job picking walnuts. They made a little money there, so they didn't continue to San Francisco, and they came back to Redlands. They lived . . . right on the corner of Stuart and Oriental. There's where the, a lot of the Spanish people were, Mexican people were before." This photograph shows Augustin Ruiz in 1979 on Cypress Street. In the 1990s, through the efforts of his descendants, Second Street was renamed Ruiz Street in honor of the patriarch, who lived to the age of 104. (Courtesy Helen Cabral.)

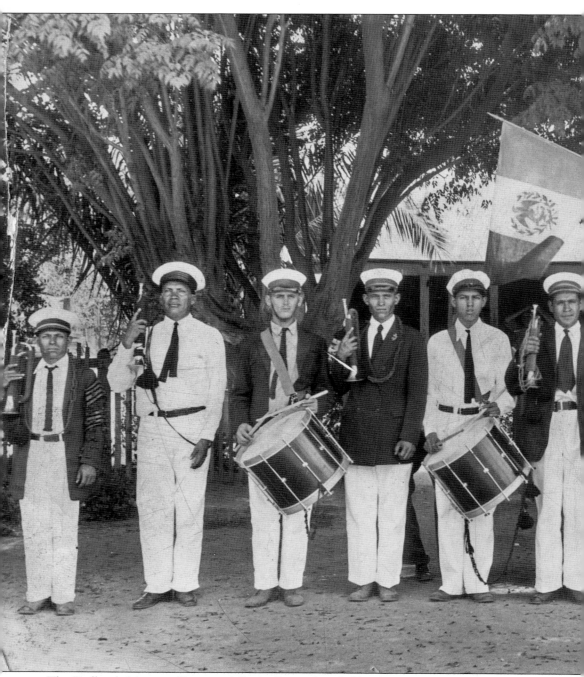

The Redlands Mexican Drum and Bugle Corps, founded by drummer Leopoldo Gonzalez and bugler Manuel Manzanales, poses in front of the Manzano family home on Tribune Street in the late 1920s. Tom Manzano, shown in back holding the flag, recalled that his parents let the group drill on their property. Other musicians in the group were Joe Delgado, Sam and Nick Coyazo, and members of the Manzano family. Often accompanied by a 60-piece boys marching band, the group performed and competed in venues across Southern California. Sponsored by

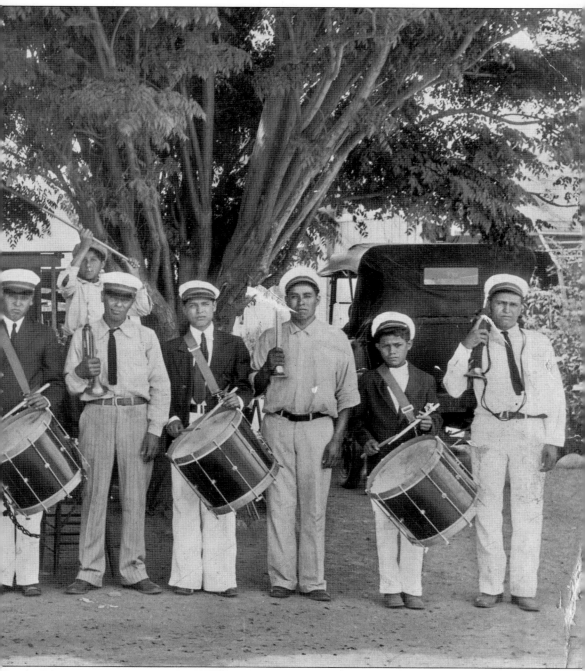

the Mexican American social clubs El Junto Patriotico and the Alianza Hispano Americana, the corps played popular and patriotic songs from the United States and Mexico. According to cornet player Howard "Joe" Herrera (fourth from left), the group would be featured frequently at Mexican celebrations like Dos de Abril and Cinco de Mayo. He recalled, "We would come marching in playing *Zacatecas* or some other song like that and people would go crazy." (Courtesy Margaret R. Castro.)

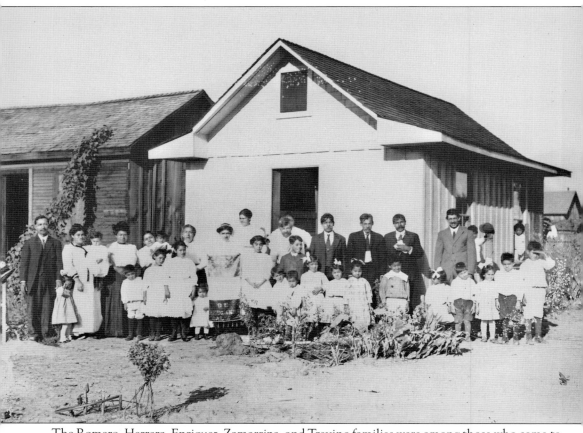

The Romero, Herrera, Enriquez, Zamarripa, and Trevino families were among those who came to Redlands around 1901 to settle and establish the first Spanish-speaking church in San Bernardino County. Built in 1913 and known as La Capillita, Iglesia El Divino Salvador was the focal point for the Mexican Presbyterian community. The church continued as a primarily Spanish-speaking congregation until 1969, when a combination of factors resulted in a name change and a move away from the conservative, Spanish-language traditions that the church was founded upon. The church was renamed Community Presbyterian in the 1990s and still serves as a spiritual home for English-, Spanish-, Mandarin-, and Cantonese-speaking congregations.

Ramon Romero, one of the founders of the Divine Savior Church, sits with his granddaughter Esther Romero at 1140 Ohio Street in the 1920s. The Romero family lived on the same street for over 100 years. Another granddaughter, Ramona Romero Dalhberg, wrote in a letter to the author, "My grandfather used to have a horse named Jack and a cart and on Sunday mornings they would hold church meetings on street corners, like Calhoun Street and Brockton and different places. Then the men got together to talk about forming a Presbyterian Church. Gavino Trevino owned property on the corner of Webster and Union, which he donated, and they drew plans for a building. The building consisted of one large room with the front door facing Webster Street. It was a very well made building with a big porch in front."

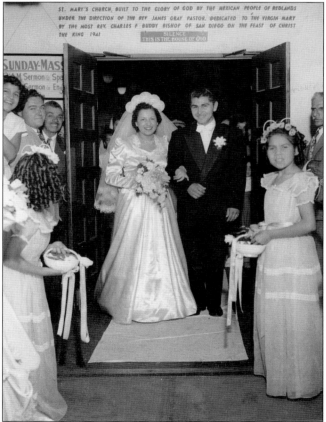

For most Mexican residents of Redlands, attendance at Our Lady of Mercy Catholic Church was an important part of their week. By the 1940s, the congregation had grown to the point that a new home was needed. Lupe Yglesias reflected on its origins: "Well, you know, before I forget, I was just thinking, all the Mexican ladies got together. We needed a church. So they would all—Concha Viramontes and some other ladies—would go once a month to collect from every Spanish family. One dollar a month to build the church. So actually, the Mexican people helped come up with that church, then it became St. Mary's."

Jose and Irene Gonzales leave St. Mary's after their wedding in 1947. (Courtesy Joe Gonzales Jr.)

Two

BLOODLINES

Legal segregation and racial discrimination based on color and preferences for "White Trade Only" were not exclusive to California or by any means limited to Mexicans or people of African ancestry. In nearly all of the interviews, stories of these institutions and their manifestations, from separate or restricted public facilities to limitations on trade and real estate transactions, were hauntingly similar.

Oddie Martinez achieved many firsts in Redlands: first commander of American Legion Post 650, first school administrator of Mexican descent, first Mexican American mayor. This decorated veteran of World War II and third-generation native was an essentially conservative, upstanding member of Redlands' professional class. The following excerpt from his 1995 interview provides some idea of how most Mexican Americans in the community felt:

> Redlands had always managed to keep things kind of calm and to sweep things under the rug. But we always knew, and I'm not sure why and how, but we always knew that we belonged on our side of town, you know? I can remember where people would come to buy homes in Redlands and the realtors themselves would keep them away from the Northside and tell them, "You don't want to live there, you want to live over here. This is for the Mexicans on this side of things." Those things existed, Bobby. And for anyone to tell you that did not exist, they are not being very honest with you. But the point I'm making is that we knew as we were growing up that there was definitely a boundary. The boundaries at one time, if you lived north of Colton you were in the barrio, or in north Redlands. So the farther south you went, the more affluent people thought you were. You would be surprised how many of my own colleagues and friends have said to me, "Why don't move out of that barrio?" And I said, "Look, I've lived here most of my life, I was born right next door, and I'm going to die here."

Martinez passed away at his home on Lawton Street shortly after this interview.

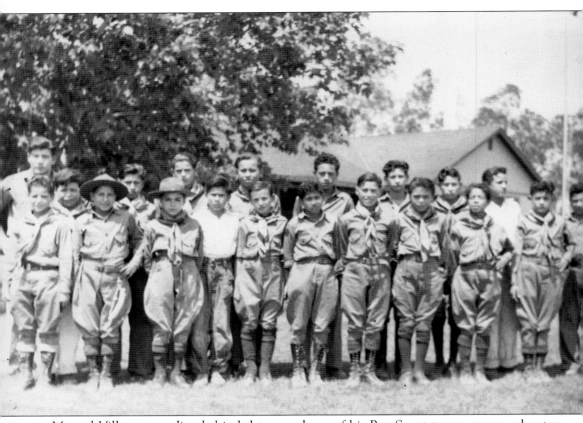

Manuel Villegas, standing behind the second row of his Boy Scout troop, was an educator, health and fitness advocate, and Olympic-class weight lifter. Villegas influenced a generation of young men and women with his determination and courage as he broke color barriers at locally segregated institutions before and after World War II. Known to all as "Manny," Villegas was a popular schoolteacher who donated much time to community service.

Married, in his late 30s, and a new father, Blas Coyazo volunteered to serve during World War II. In 1944, he was stationed at the Columbia Army Base in South Carolina with a Military Police unit. After experiencing segregation at home, from barbershops to the local roller rink, Coyazo was amazed to find himself in an all-white unit with access to facilities far superior to his black comrades, who were housed at and fought in segregated units. The following letter was sent on January 1, 1945, to "Pelanchos" and Carlie: "Here I am with the boys from the 2nd Relief. I have white gloves, white leggings an M.P. band and a holster with my lassito around my shoulder, only it can't be seen, it's too bad. But anyway here I am, hope you can find me. With all my love, Blas." Below is an unidentified soldier home for a visit with Joe Hernandez (second from left) and picking foreman Ismael Tejada (far right). (Above, courtesy Blas Coyazo; below, courtesy Sam Coyazo Jr.)

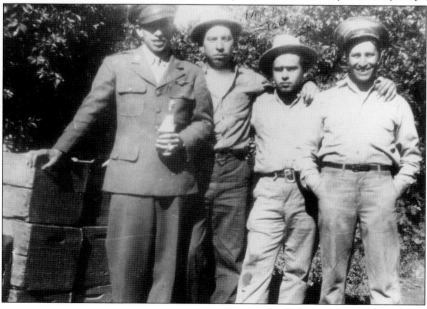

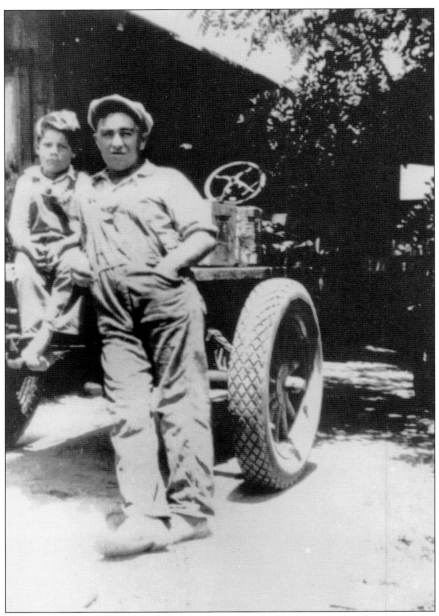

Wally Sanchez and his father, Chris Sanchez, are pictured here around 1928. Wally became a star college athlete and popular educator in Redlands. He served in the Air Force during World War II. He recalled social barriers in Redlands and his first time traveling in the southern United States: "[Redlands] was a very highly prejudicial town I remember that much. I mean, there was, in fact, they had signs in the cafes there that said, 'White Trade Only,' and it was really something to see this sort of thing. Then we went from here to Nashville, Tennessee; that was my first wide awakening where I saw the drinking fountains, you know, 'Blacks Only' and 'Whites Only' in grocery stores and restaurants. But prejudice can just make you strong. I mean rather than let it defeat [you], all you have to do is just keep fighting it, and it makes you strong. I mean you can either succumb to it, or you can overcome it."

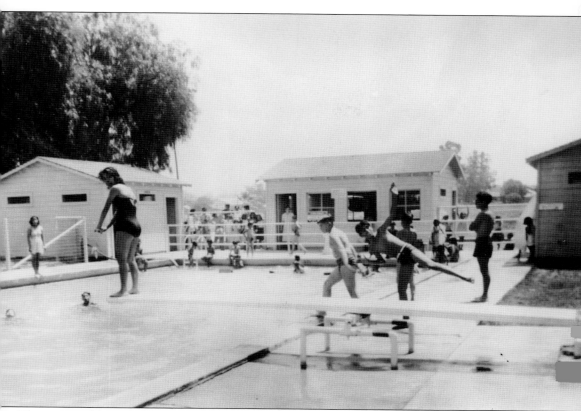

This is one of the only known photographs of the Redlands Floral Plunge. Located on Oriental Avenue, the "Mexican Plunge" was built and run by the House of Neighborly Service, a Presbyterian community service organization that provided everything from cultural enrichment to after school programs, childcare, and laundry facilities. Located a short distance up the railroad tracks was the Sylvan Plunge, a much larger and better-equipped facility open to Mexicans one day a week—the day the pool was cleaned. Although the Floral Plunge was used by many in the Mexican community, some parents refused to allow their children to patronize segregated facilities in a town where they "paid taxes, worked hard, and owned homes," as noted by Carl Sepulveda. In the 1960s, the aging Sylvan Plunge was desegregated, and the Mexican Plunge was turned into a private swim club for Anglo youth. By the 1980s, both pools had been demolished. (Courtesy Armando Lopez.)

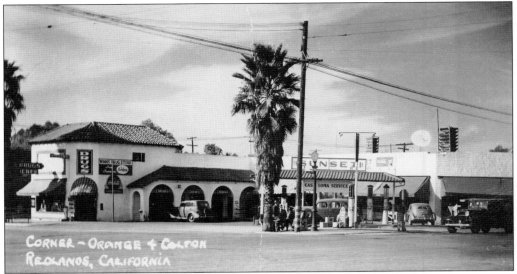

Sunset Market, Winn's Drug Store, and the Casa Loma Service Station opened at the corner of Colton and Orange, on the site of the former Wyatt Opera House in the early 1930s. Aurelia Ruiz Reyes recalled other businesses that provided goods and services to the Mexican colonia: "Don Sabas we used to call him. Well, that little store [on Colombia Street] belonged to that man first. No, no, it belonged to Japanese people, and then he took over. Then when the war came he took his son to Mexico, and that's when Tommy [Martinez] bought it. Tommy had it for a long time, and that was the only little store. This other man had a bakery of Mexican bread right there on Lawton Street in front of the House of Neighborly Service. My brother-in-law used to have a little gasoline station on Stuart Street right across from Sam's Café. Oh, there was the Resbalon, a bar where they used to have food, it was a wife's help for their husbands to go." Below is the corner of Orange Street and Central Avenue, the commercial center of Redlands in the 1920s. (Below, courtesy Leland Richardson.)

This unidentified man stands in front of a common symbol for the era, the segregated barbershop. For decades, segregation in shops and services was common in Redlands. Manasses Soto recalls: "When I'd go downtown to get a haircut I couldn't get a haircut because the signs said, 'For Whites Only' and that kind of disturbed me because I was a student going to school and I couldn't see it in school with the students too much, but the adults seemed to push it on us. The only person that would take me to give me a haircut was Abe. We used to call him Abe Lincoln. He had whiskers and he had a barbershop downtown, and he used to go every year when they had the Lincoln Memorial Parade and they had a celebration for Lincoln at the Bowl, he would go and give a speech and that was very enjoyable to see the guy that gave me the haircuts." (Courtesy Sam Coyazo Jr.)

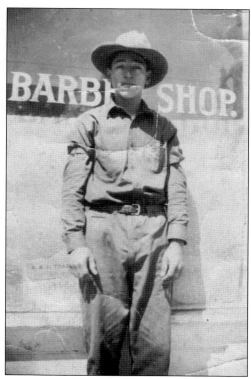

Palmer Leland "Richie" Richardson married Tomasita Vellarde in 1913. During the 1930s, he owned and operated Richie's Garage in downtown Redlands. (Courtesy Leland Richardson.)

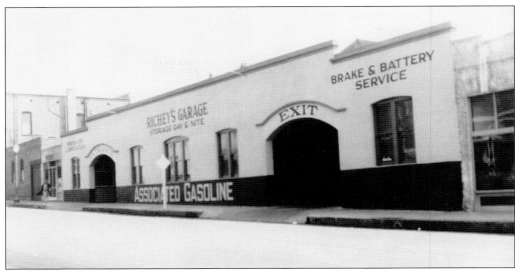

Richie Richardson's daughter Rita Richardson Radeleff was a retired bank executive who did considerable research into her Mexican and Scottish family background. Her family's story provided insights into the depth and diversity of Mexican family life in Redlands and about early settlement in south Redlands by her Mexican relatives and working-class people of European descent like her father. She remembered, "Dad's garage was 24 hours. When he wasn't there, my two brothers were there, Mateo Guzman and Leland Richardson. They would kind of let dad have some rest while he went home to eat and sleep, or he slept right there in the garage many times, too. But being 24 hours, it was miserable. He got all of the accidents from all over the area. He had a great big Maxwell touring car that was a tow truck." (Both photographs by Palmer Leland Richardson; both courtesy Rita Richardson Radeleff.)

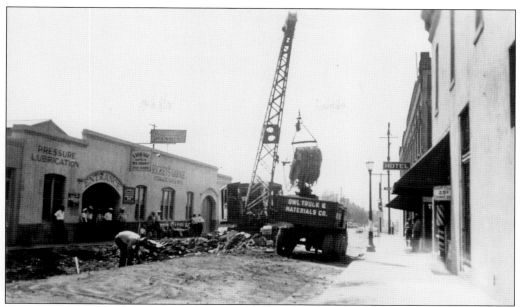

Lee Richardson was in his 80s when he recalled growing up in Redlands working as a newsie and a caddy and helping out in Richie's Garage. "Well that was Depression time after the 1929 stock market crash and everybody in the early '30s was having a problem making a living. That's when my dad bought the garage on 17 West Central. We were fortunate enough to get the storage from the La Posada Hotel at night, the cars coming in, I stayed down there and took care of those. My dad would come at 4:30 in the morning and relieve me, then I would go on and peddle my *Examiner* papers." (Both photographs by Palmer Leland Richardson; both courtesy Rita Richardson Radeleff.)

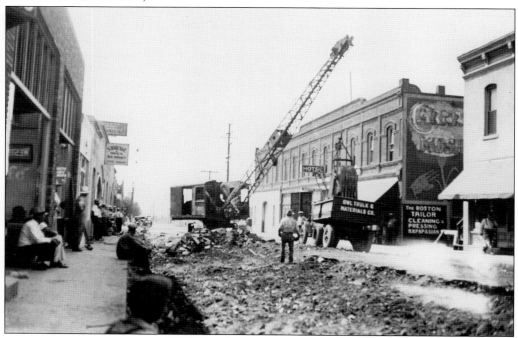

Richardson worked in the garage until 1936, when he took a job with Douglas Aircraft. He recalled, "Later on, they put the highway right straight up Central Avenue and cut off half of the front of our garage. So that was wide open then to the elements, because they cut off most of the roof, but I stayed down even then. Previous to that, all the trucks and everything that came through town, they'd come up Colton Avenue, go down Orange Street, turn left on State Street, then go up past Redlands High School, and on up Reservoir Street." (Courtesy Rita Richardson Radeleff.)

Regardless of the hardships of the Depression, by the 1930s, improved roads and access to motorized vehicles gave people old and young more mobility and opportunities to work and to travel. Leo Cordero, shown standing outside his home on High Street, would travel with family to job sites across California. Jessie Ortiz is pictured below with her friend near San Timoteo Canyon in the late 1920s. (Both, courtesy Nellie Del Rio.)

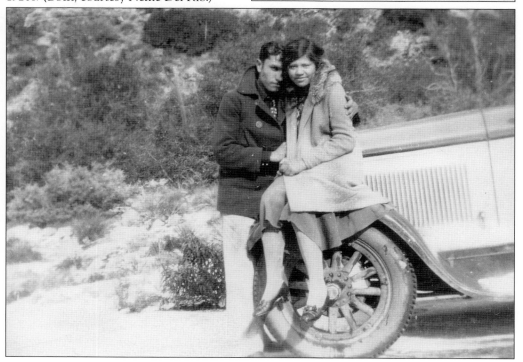

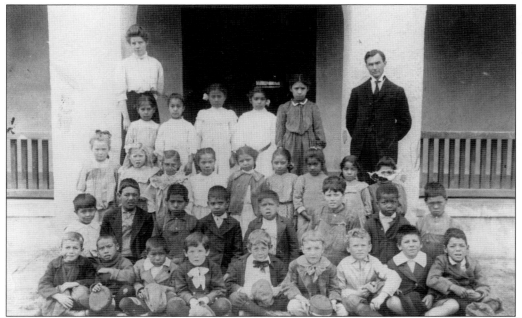

Lincoln School in 1910 was officially segregated, but in Redlands, children from the Mexican colonia went to Lincoln, Lugonia, and Franklin Elementary, mixing with children of other ethnicities from their neighborhoods. (Courtesy Mary Garcia.)

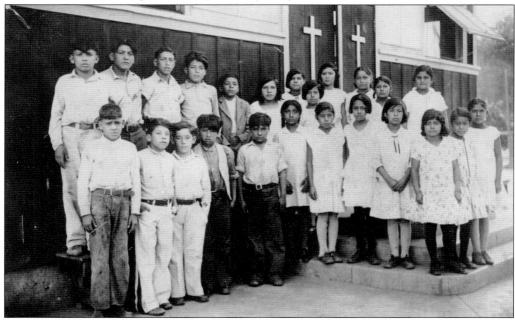

Lupe Yglesias recalled that "all the Mexican kids went to Our Lady of Mercy here on Calhoun, where this picture was taken. In fact, you will see a lot of the Roques are in the picture. In the picture you can see the building, which burned later. We had the school and then later, on Sundays, we would have mass. They would open the doors for the whole people." (Courtesy Margaret R. Castro.)

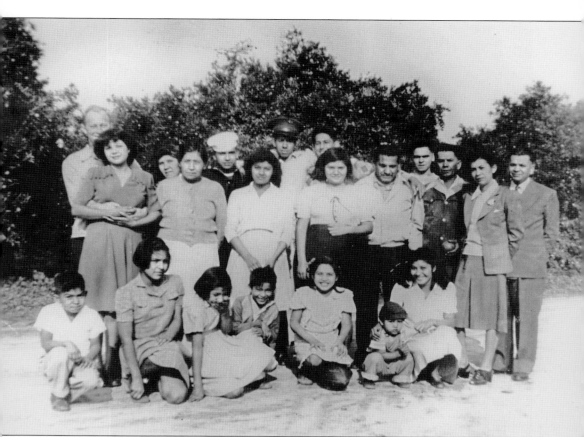

Though uncommon for the time, due to strict segregation and racial prejudice, early Mexican and Anglo families intermarried. This photograph shows three generations of Ramon Romero's family gathered at Fairbanks Ranch in 1944, including his granddaughter Ramona and her Swedish husband, Harris "Harry" Dalhberg (standing on the far left). The ranch, comanaged by Dalhberg and Ramona's father, Jacinto "Joe" Romero (second row, third from right, holding orange), extended along Highway 99 from California Street in Redlands to Mountain View Avenue in Loma Linda. Eunice Gonzales (second row, center, in dark skirt) reminisced about ranch life: "They had groves of oranges, groves of grapefruit. And they had lemon trees. The Castillos lived on one ranch, the Bowmans lived on one ranch, the Martinezes lived on another ranch. So then the Romeros lived on another ranch, the Dahlbergs, the Coyazos lived on the Fairbanks Ranch. Those were people that socialized and worked together."

Eunice Romero Gonzales, pictured at left, was a bilingual instructional aide in the 1970s. She recalled one of the biggest controversies ever to engulf the Northside, "When my children started going to school, there was always this measure of prejudice, especially when they started with this business of integrating the schools. You could see the prejudice, that these people didn't want our kids from the Northside at their schools any more than we wanted theirs over here, because it was a two-way street. So, early on, Lincoln School closed up and our kids were shipped, some to McKinley, some to Kingsbury, some to Mariposa, those were the schools that were targeted. They took the better part of the Northside and distributed them to the Southside." Nellie Hernandez's fourth-grade Lincoln School class photograph from 1935 is pictured below. (Below, courtesy Nellie Del Rio.)

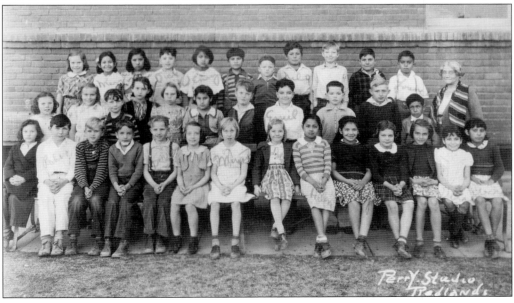

Eunice Gonzales, who was active in the parent-teacher association (PTA) and community groups, continued with her thoughts on race relations: "There were other measures of prejudice. I think you have heard this before about using the plunge, using the skating rink, going to the movies. You had to sit in certain spots; you couldn't venture anywhere else 'cause you'd get thrown out. And always the prejudice of prices being hoisted a little more when you were a different color. But in the long analysis, maybe it was my attitude or my desire to have my children get educated that let me live through the turmoil that the Northside went through, because I then changed my mind about integration and I spoke out for it in several public meetings. I had nothing but good things to say about the schools up there."

Lincoln School

Parent-Teacher Association

515 Texas Street

PH. 792-3281

Program 1965-66

Theme of the Year

"Our Responsibility-To Care, To Plan, To Follow Through for Youth"

Redlands Council, Fifth District

Redlands, California

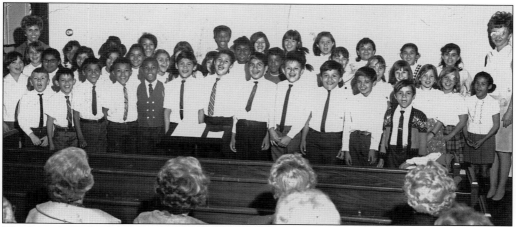

The Lincoln School Choir performs at Divine Savior Church in 1967.

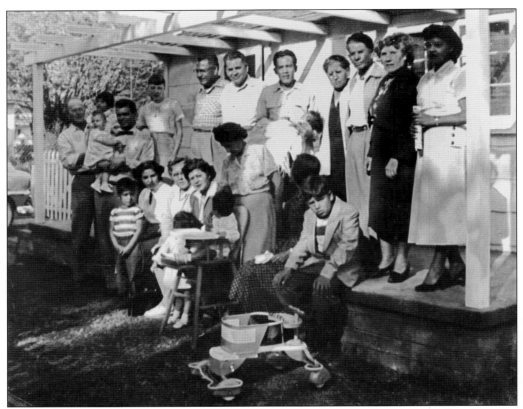

Ramon Romero's descendants gather for Thanksgiving in 1951 at his home on Ohio Street in Redlands. Rafael Gonzalez is pictured standing in the center holding his infant daughter Christina. Among the younger women and children in the photograph are Joe and Concepcion Romero's daughters and grandchildren.

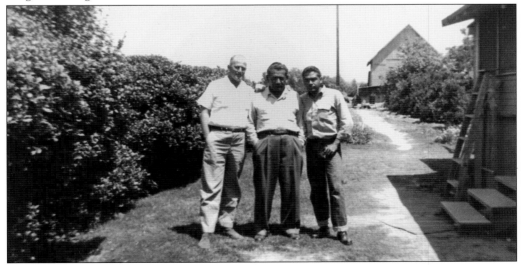

Harris Dalhberg, Ben Romero, and Frank Romero are shown here working at Fairbanks Ranch in the late 1950s.

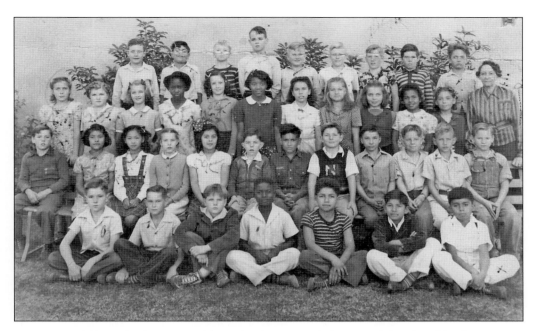

Miss Wray's fifth-grade class at Franklin School is pictured above. Melida Silvas (third row center wearing white dress) grew up on High Street and attended this integrated school in the 1940s. Miss Heron's fifth-grade class at Lincoln Elementary is pictured below in 1937. Nellie Del Rio is in the center with her arm around a friend. Regarding the Lincoln School controversy, longtime community activist Rose Ramos recalled, "I could stand on my front porch and watch my kids walk into the schoolyard everyday. That's one of the reasons I didn't want it closed. Parents were more against closing the school. . . . It was like separating families, their roots. . . . In fact, I got up one day at one of the meetings I said, 'When you look at my kids all you see is dollar signs,' I said, 'you're not looking at children.' " Lincoln was reopened as Orangewood Continuation High School in the 1970s. (Above, courtesy Sandra M. Medina; below, courtesy Nellie Del Rio.)

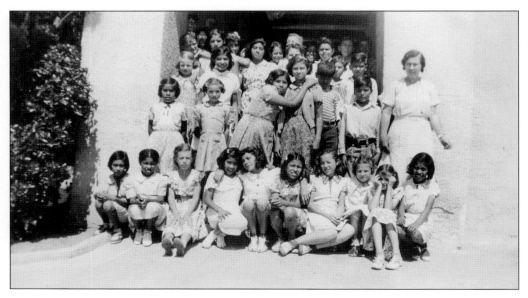

Students cross Fern Street in front of Redlands High School in the 1940s. As a young teacher at Lincoln in the late 1960s, Wally Sanchez was witness to the last days of the school: "I thought we were getting along real well. I thought, you know, the way the kids were responding to the instruction up in the fifth and sixth grade level. Because I talk to them today, I see a lot of them, you know, and they said they learned more there than they learned any place else. If they'd have left the kids alone and got the proper teachers in these areas they'd have done beautifully." Below is a sixth-grade class at Lincoln School in 1938. (Above, courtesy Margaret R. Castro; below, courtesy Nellie Del Rio.)

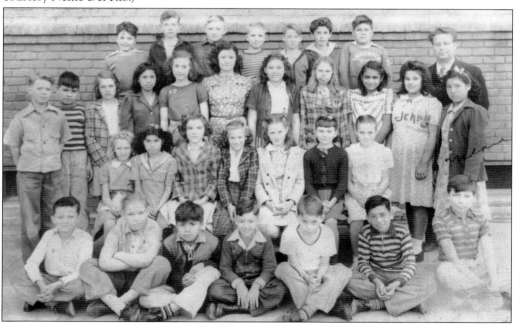

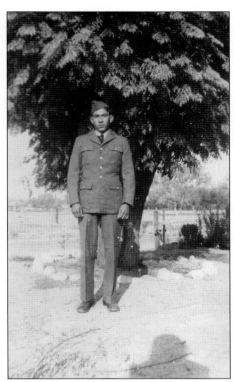

A member of the Roque family poses in uniform during World War II. In a 1994 interview, citrus rancher Bob Garcia related this incident: "I used to work with a guy in Bakersfield, and he and I used to go for coffee every morning and we'd eat dinner all the time. We used to get along real well. One time we got into a little argument, he says, 'Yeah, but you're Mexican!' I says, 'What the hell are you? You know what, my folks were here before your folks was here.' When people ask me, 'what are you?' Well I tell them, 'I'm an American. Primarily, I'm an American of Mexican descent, what are you?' They tell me, 'English.' I tell them, 'Well, do we call you American English or American French? Because they call us Mexican Americans.' " Below, the Roque family relaxes at Huntington Beach in the 1940s. (Both, courtesy Margaret R. Castro.)

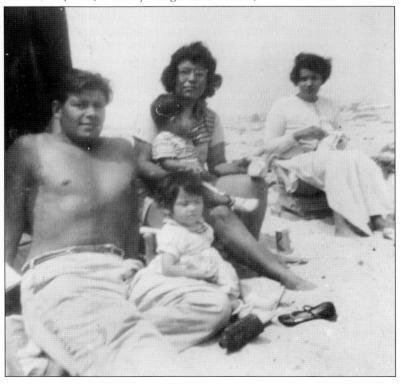

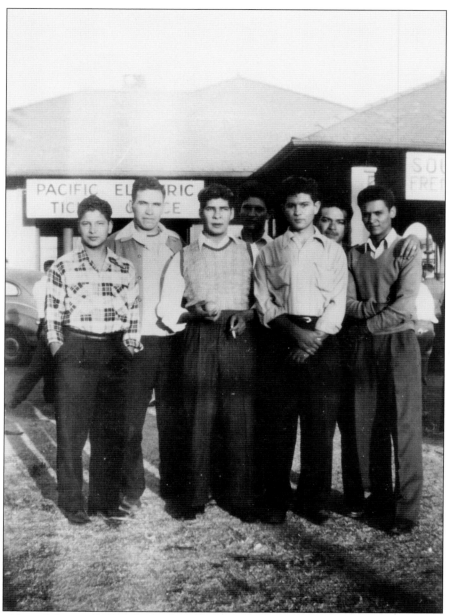

Pictured from left to right, Joe Guerrero, Lalo Ramirez, Peter Ruiz, Tony Torres, Leonard Torres, Marion Torres, and Frank Coyazo depart from the Pacific Electric Depot in 1943 for duty during World War II. Oddie Martinez later commented about how war changed the young men who left home to fight: "I realized immediately when I joined the Navy and I competed against college graduates, I could immediately see that these people were not any better or any smarter than I was. I think that attitude prevailed with a number of people that served during World War II because that brought all different types of cultures and races, different people together. I think we learned a lot of lessons in that if we were determined enough to do what we wanted to do, it could be done. I think many of our people came out of the service with a different attitude, you know, that they were not going to be pushed around anymore, that they were going to compete."

Three

LIFELINES

Before World War II, the citrus industry was the largest employer of Mexicans in the Redlands area. Most of the people interviewed for this book had some connection with citrus, but making a living took a number of forms in and out of the groves and packing sheds. While work is important to life, social and recreational activities are a necessary part of any community. Opportunities to express pride for both their Mexican heritage and adopted American culture were available to Mexican Americans in early Redlands regardless of the barriers of racism and segregation that strongly influenced the generation of young men and women who worked, fought, and came of age during World War II.

As early as 1917, attempts were made to organize agricultural workers in the San Bernardino Valley. However, no movement before World War II saw success, due to strong industry resistance. Carl Sepulveda recalled the following incident:

> There was a farm worker's union that for a long time was trying to organize the pickers in Redlands. Theodore Krumm was one of the bigger orange growers in Redlands and he advised my cousin, who was sending out over a hundred workers to pick oranges a day, told him that whenever the union representatives [showed up] to call him. Well this one particular morning, I was going out to pick oranges. There was a big yard in front where they kept all the ladders and trailers, and so all the orange pickers used to gather there in the mornings to be sent out on the different crews. Well, when these union organizers showed up one morning, my cousin called. So, here he comes, here comes Captain Krumm with several police officers. They took these guys to jail that were trying to get the pickers to sign up for the union. They weren't using any kind of strong-arm tactics or anything, just asking them if they wanted to join the union. I think there was four or five of them. [They] hauled them off to jail. That Captain Krumm, he was a real tough man.

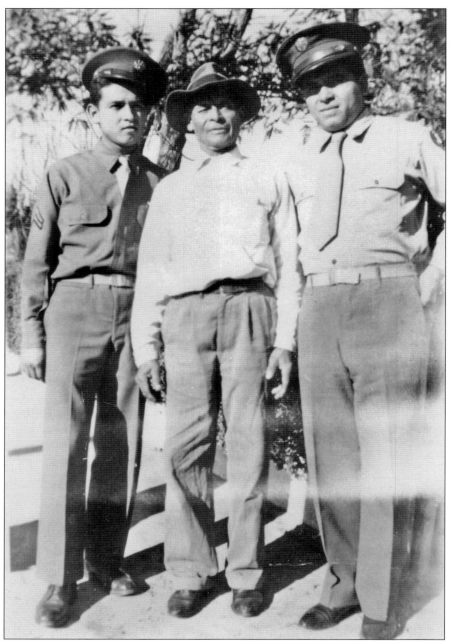

Blas Coyazo and Cruz Coyazo both served in Europe during World War II. Cruz was a tailgunner and was shot down over Belgium. His body was never recovered. Blas, right, tells of his time in the service, "I spent almost four years in the service. I would serve some of my time in Europe, I went to Germany. At first, I was in the Air Force, and then they transferred us to the infantry. You will recall at the Battle of the Bulge; they lost a lot of men in the infantry and we were going to be replacements for those men that they needed in that battle that they lost. However, when we got to Germany, things were looking very good. The German army was just about ready to give up, and they did. But I stayed a year in Germany—Army of Occupation they called it."

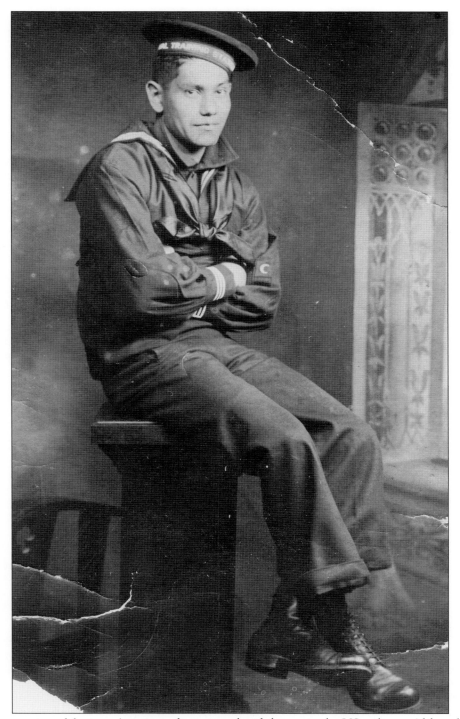

For generations, Mexican Americans have served with honor in the US military. Although the name of this young naval seaman remains unidentified, we pay tribute to those who served and their families. (Courtesy Sam Coyazo Jr.)

From unknown civilian to unknown soldier, this young Redlands man prepares to ship out in the early 1940s. Coyazo, who served in Korea, recalled, "I got shipped to the state of Washington to Tacoma. That's were we boarded a ship when we went overseas. For 21 days, we were on that ship. I got so tired of water, I mean, I real got tired of seeing water. Then, when we got to Korea, they didn't have a port or nothing." (Both, courtesy Sam Coyazo Jr.)

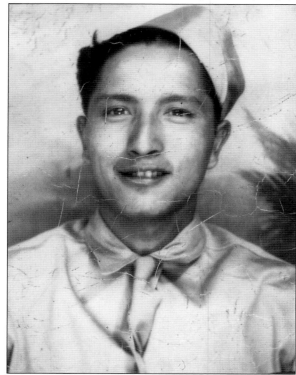

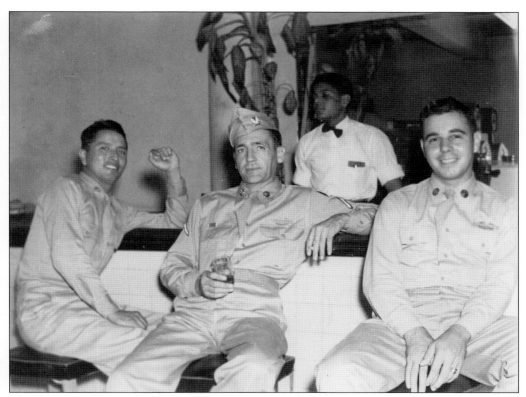

The above image was taken at Panama City in 1947. The soldiers are identified from left to right as "Babe," "Mac," and "Nello." Before mustering out, the three unidentified soldiers below relax for a photograph home. Mexican Americans have fought and died in numbers far greater than their share of the population in military conflicts around the globe. But often military service was a way to expand horizons, travel, and engage the world outside Redlands and the San Bernardino Valley. Veterans from Redlands and the surrounding area served in every theater of operation during World War II, many returning home to assume leadership positions in social, political, and economic spheres undreamed of before the war. (Both, courtesy Sam Coyazo Jr.)

Two generations of the Roque family in the military are depicted in these images. Soldiers were supported by their families at home who volunteered, wrote letters, and prayed. Margaret Roque Castro recalls the anxiety of those dark times: "See, two of my brothers were in the service. One of them served in the Aleutian Islands and the other one in Italy. . . . The worst that I remember is when they would, people would see the guy with the telegrams coming, he came on a bike. People would go out there and see where he was going, because they were afraid one of their loved ones was killed or missing in action. It was a scary time. My mom would cry, and she was so worried and always praying, always praying for her sons." (Both, courtesy Margaret R. Castro.)

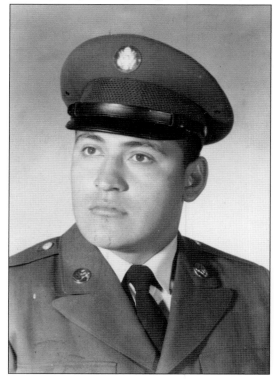

Women played a prominent role in the workforce from a young age during the war. Activist Rose Ramos recalled, "I started working three days after I graduated from high school [in 1943]. I started working at Norton [Air Field]; I worked at Norton for 15 years. I rode a scooter looking for parts. . . . It was a lot of fun and a feeling of doing your duty. I started work at $1,200 a year, and that was a lot of money at that time for someone who was just barely 18 years old." At right, an unidentified woman heads to work at Norton Air Force base in the 1940s. (Courtesy Sam Coyazo Jr.)

Returning servicemen, including future mayor Oddie Martinez, were instrumental in forming American Legion Post 650. In his 1988 commemoration, author Gilbert Rey noted the words of a comrade at the dedication of the post, "Hey, a bit of Redlands history is in the making tonight, but who will ever read about it?" (Courtesy Gilbert Z. Rey.)

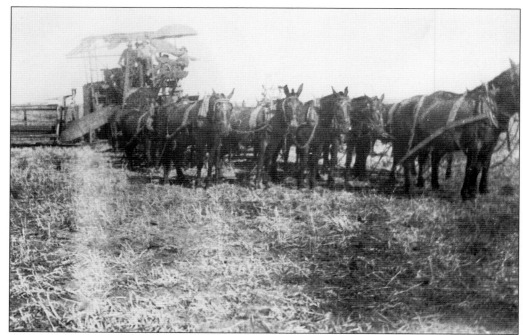

Through war and peace, through times bad or good, work was a constant for Mexican Americans. Labor took on a variety of forms both skilled and unskilled, and knowledge gained in fields such as concrete, masonry, and construction were passed down through families over time. The image above shows a hay-baling machine owned by Bob Garcia's grandfather. Garcia remembered, "He [My grandfather] would take it all over the place, Yucaipa, Moreno Valley, and rent it to folks."

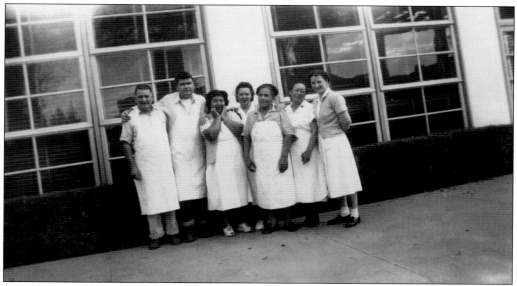

Nellie Del Rio's grandmother Julia Alvaraz is pictured above (third from the left) with her coworkers at the University of Redlands Commons in the 1950s. (Courtesy Nellie Del Rio.)

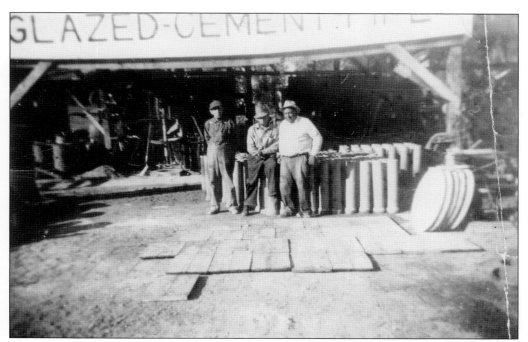

Mary Garcia's father, Manuel Jacques, is pictured here at a concrete manufacturing plant on Colton Avenue in Redlands. Manuel Reynoza, a contemporary of Jacques, recalled that owner had a love for cigars and swearing. Concrete conduit, standpipes, and other molded products were essential to the citrus industry in the days before plastic tubing. (Both, courtesy Mary Garcia.)

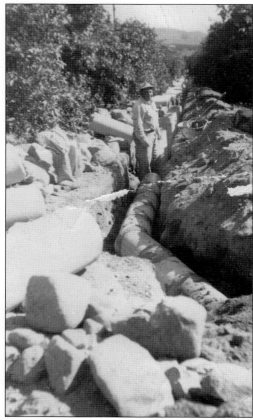

During the late 1930s, Sadie Cordero and her children pick grapes in Salinas. Though not representative of all Mexican families in Redlands at the time, a common seasonal ritual is pictured here. For many, following the crops was a matter of survival in the absence of local, full-time, year-round work. Families would spend summers and the early fall months harvesting crops throughout California and other parts of the West. After the war, a few locals continued to travel, but they remained based in the Redlands area, where their families lived. As a teenager, Aurelia Reyes recalled: "We would go up north, come to think of it, for the fruit. We were fruit tramps. It was fun, we were teenagers, so we liked it. Just before the war, we started going to Fairfield, California, and we would cut peaches, pears, pick prunes. We went to pick walnuts in Concord, California, and we'd just travel after that." (Above, courtesy Nellie Del Rio; left, courtesy Margaret R. Castro.)

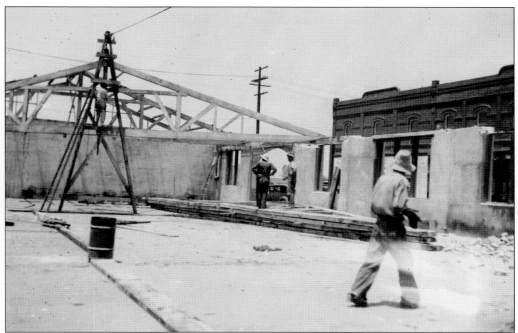

For some, the construction trades offered reasonable wages and ample work. Mexican American entrepreneurs would go on to establish construction firms of their own. Some women, like Concepcion Romero (below), ran restaurants and made both tortillas and tamales. Her daughter Eunice Gonzales noted, "My mother had a restaurant right here on Colton Avenue, on Lawton and Colton. There was a gas station and then a little restaurant, and my mother ran that. And then she ran a tortilla factory and restaurant up on old Third Street, and then her final restaurant was on Stuart and Third Street, and they were all Romero restaurants." (Above, courtesy Leland Richardson.)

Epimenio Guzman is pictured on the left at a blacksmith shop in this image from the early 1900s. Rita Radeleff, in an excerpt from her unpublished autobiography, fondly reminisced about her uncle "Goose," who ran the shop on Stuart Avenue. She wrote, "Goose would produce a nondescript piece of metal and heat it in the fire until it was glowing red, pounding it on the massive anvil, bending and twisting the metal until it was fashioned into a shoe for the horse, which was waiting so patiently to be shod. Oh, how the veins on his arms and massive hands would pop out, I thought that they were going to burst! He would talk to the horse making it stand so still as he fit the shoe to the hoof, never hurting the horse though. He would then trim whatever damaged or excessive hoof, just as we would receive a manicure." (Courtesy Connie McFarland.)

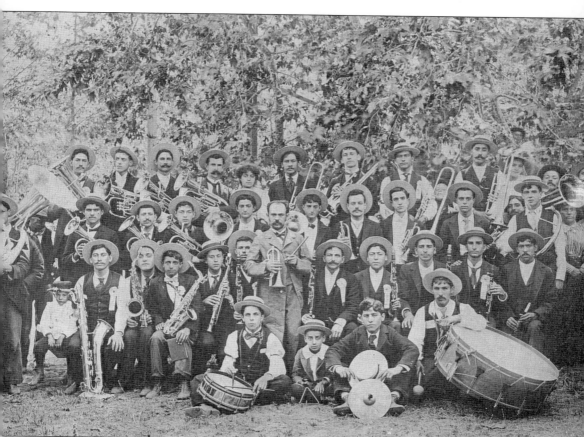

Many Mexican American residents found relief from their long workweek among a number of cultural and social activities available through family tradition, church, or patriotic organizations. In his spare time, Epimenio Guzman was a musician. This 1920s image of the Redlands Mexican Philharmonic Orchestra testifies to the depth of community and culture in early Mexican Redlands. Not much is known about the group, led by Prof. Juan Balderas (center, holding cornet), but Epimenio's granddaughter Connie McFarland recalled, "That's the band right there, that's my Grandpa with the saxophone [seated second row, fourth from left]. He said they used to play at the old opera house at the corner of Orange and Colton Avenue. It was called the Wyatt House." (Courtesy Connie McFarland.)

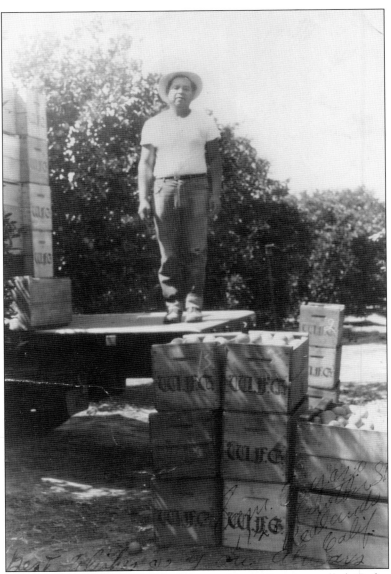

Sam Coyazo was a foreman for Western Fruit Growers. His son Sam Jr. recalled: "Before World War II a siren was used in the early evenings to alert people that they would be needed for smudging that night. The siren alert for smudging ended when the war began because we started having practice air raids. About 1938, a grower named Mr. Cook had a telephone installed in our house so that when smudging was necessary, he could call my dad and dad would pass on the word to others. Our family was the only family in a seven-block radius that had a telephone." In a 1994 interview, Felix Sepulveda described the foreman's job: "It was up to me to make my crew, which was about 18 men. If someone quit, I would have to be sure to replace them, because we used to get paid by the box. It was 7.5¢ a box, so the more people you had, the more money you would make. They used to pick 1,500 boxes. One time they picked, the best day they picked 1,986 in one day. If anybody got hurt, it was up to me to take them to the doctor. I was also supposed to provide transportation. If a guy wanted to take his car, I would give him so much a head for each picker he took. I had a big '41 Oldsmobile so I could always take five there." (Courtesy Sam Coyazo Jr.)

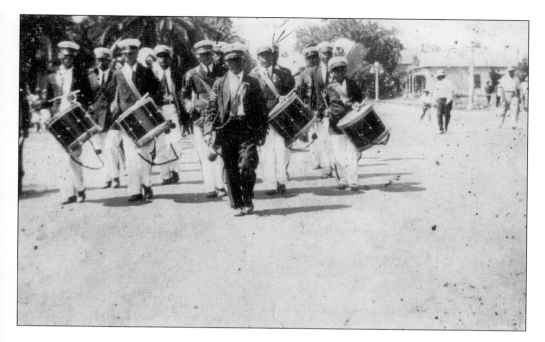

The Mexican Drum and Bugle Corps is shown here marching down Colton Avenue during the Dos de Abril festivities in the late 1920s. Sam and Nick Coyazo were members of the popular musical group, which was sponsored by Mexican patriotic and fraternal organizations. (Both, courtesy Sam Coyazo Jr.)

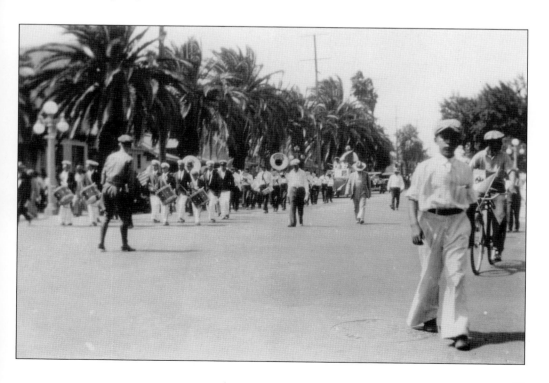

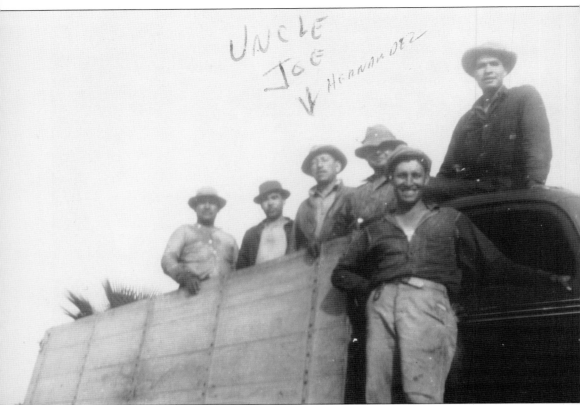

Veteran citrus worker Joe Hernandez, standing center on the truck, was among the crew headed by Ismael "Smiley" Tejada (standing on the truck's running board). Carl Sepulveda describes a typical picker's day: "If it was too early, the trees stayed wet and you couldn't really pick. We'd have to wait until the sun would come up and kind of dried them off a bit. We had what you call 'sets.' It was a set of trees that belonged to you. We'd go in and pick and at the end of the day, the foreman would ask how many boxes you picked. He had a book and he used to keep track also, so you couldn't say, 'Well, I picked a 105 boxes today' because he'd jot down the number of boxes that you had filled in his little book, and by golly the count you gave him at the end of the day better match up with the count he had, because you'd lose every time." (Courtesy Sam Coyazo Jr.)

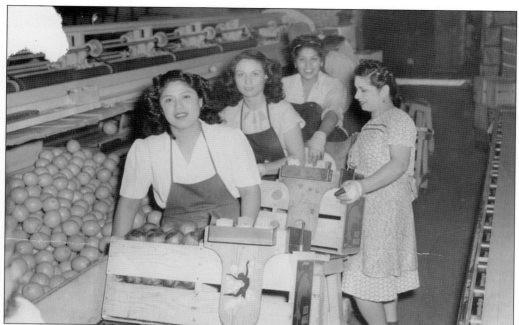

Dora "Chita" Avila heads the packing line in this promotional photograph taken at Peppers Packing House in the 1940s. Nellie Del Rio is the third packer on the line. Eunice Gonzales described the jobs and routine of the house: "The bulk of the work in citrus was at the packinghouses where women graded and packed oranges. The graders were women, the bosses were women, the packers were women. What the graders did was size the orange and send them down the chutes. Say they wanted to pack a 180, and a 180 is a big orange, or they wanted to pack little oranges, these graders would know in advance what oranges they were to throw down the chutes. And they had to be wrapped in paper, so you had to size the paper and the size of your orange. You wrapped it and placed it in the box and you had to put it like, one-two-three-four, one-two-three, one-two-three-four, and that's the way you packed oranges on the crates till they were full, they had to be all one size. You could not mix and match because you'd get fired." Below, Nellie Del Rio demonstrates a new cardboard box assembly machine at Southern Citrus in the 1940s. (Both, courtesy Nellie Del Rio.)

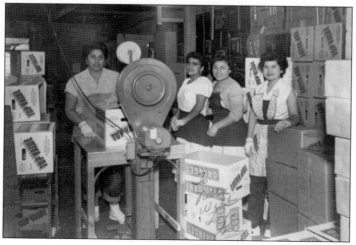

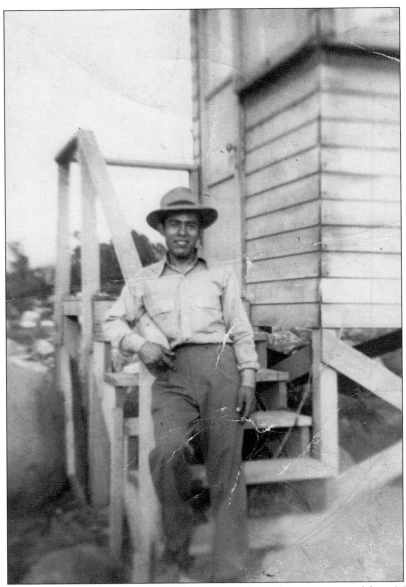

Rafael Gonzalez is pictured here at Cone Camp in 1943. Gonzalez was recruited from Mexico City as part of the United States–Mexico Bracero labor program during World War II. Coney Camp, as it was known to the local Mexican population, was a former jail and Civilian Conservation Corps (CCC) training center located on the banks of the Santa Ana River in East Highlands. Converted to house Mexican laborers, the facility held up to 1,500 men at a time. In wooden barracks and sometimes in tents, the men endured severe winter weather, corruption, and other depredations. Andres Garcia, a cook at the camp and friend of Gonzalez, recalled hearing boulders "as big as cars" crashing by only a few feet away during the seasonal flash floods. Although reasonable living conditions, wages, and medical care were federally mandated, the system was not without deep flaws that affected the health, safety, and welfare of the men. The Bracero Program was officially disbanded in 1964, but so-called guest worker programs and undocumented migrants continue to fill the need for low-cost, transient, easily exploitable labor.

In the image above, Nellie Del Rio's husband, Roger (second row, far right) works at Southern Citrus in the late 1940s. Nellie recalled that nearly all the loading dock and office workers were white, but through connections with house manager Gus Bisesi (second row, left, wearing blazer) Del Rio was able to find regular employment in citrus-packing operations and distribution. Jessie Jacques (first row, third from left) is pictured at right with a group of packers on a break from Mutual Orange Distributors in the early 1930s. (Above, courtesy Nellie Del Rio; right, courtesy Mary Garcia.)

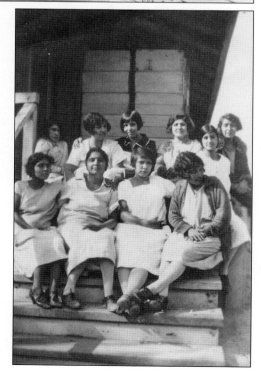

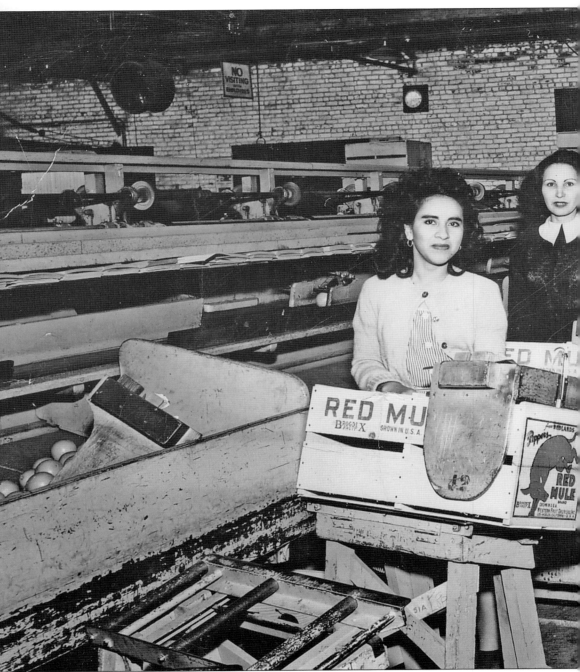

Nellie Del Rio, third from the front, packed citrus for several houses. Women who could pack 100 or more boxes a day were chosen to represent the packinghouses at the National Orange Show in San Bernardino. Sam Coyazo recalled, "In the middle 1940s and early 1950s the Orange Show would have an Orange Packers Contest. Vera Coyazo, who was married to my Uncle Tony, would win the contest almost every year. She got her experience packing oranges for the Western Fruit Growers." Packers were paid lower wages than other citrus workers, and women of color were

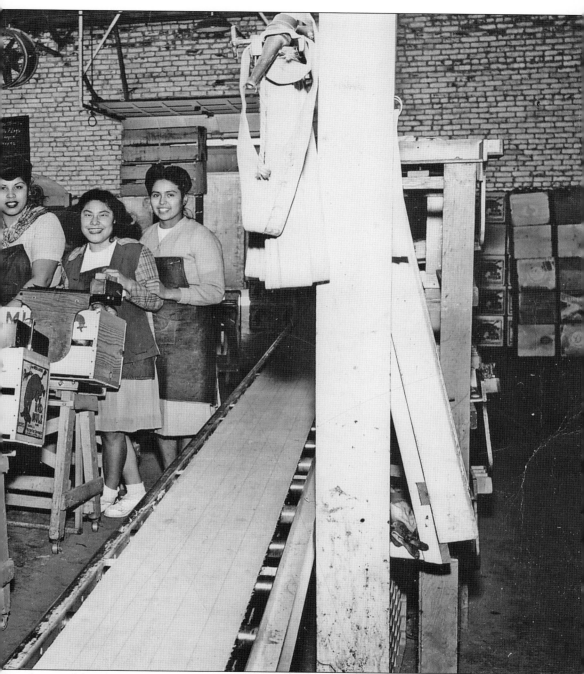

often paid less for their efforts. Margaret Castro noted: "Sometimes we had to wait around for our turn, sometimes we were there two whole hours without nothing, so we got paid exactly what we made for each box. We didn't get paid by the hour. But later on, after I was already married, which was in 1948, this lady that had worked there said it wasn't right for us to sit around and not get paid. So she made a fuss about it and that's when they started paying them by the hour." (Courtesy Nellie Del Rio.)

Certification that

LOUIS S. MORENO

IS A DULY SWORN

POLICE OFFICER

OF THE

City of Redlands, California

EMPOWERED TO ENFORCE THE LAWS OF THE STATE OF CALIFORNIA AND ORDINANCES OF THE CITY OF REDLANDS.

Robert I. Graefe

SIGNATURE OF ISSUING OFFICER

ROBERT I. GRAEFE, CHIEF OF POLICE

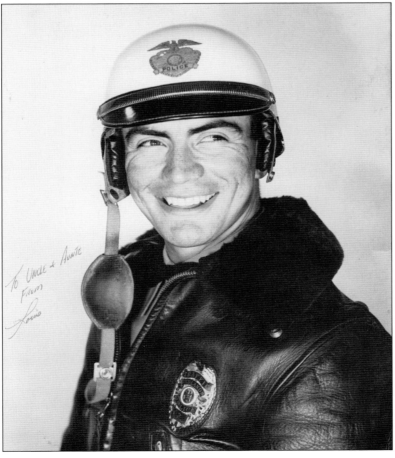

Redlands native Sandra Moreno Medina's father, Louis Moreno, was the first Mexican American police officer in Redlands. Known as "Louie the Cop," Officer Moreno was a motorcycle patrolman who began his career in 1953. (Both, courtesy Sandra Moreno Medina.)

Bob Romero was part of the extended Romero family that migrated to Redlands at the turn of the century. Bob Romero's father, Abran "Abe" Romero, was a founding member of Divine Savior Church. A past president of the Redlands Chamber of Commerce, Bob served in the military and worked many years as an advertising sales manager for the *Redlands Daily Facts*. Although never interviewed for the book, Bob donated a treasure of photographs taken of the musical *El Aguila*, a pageant produced in Redlands during the 1930s. Similar to the popular Ramona and Padua Hills Pageants, *El Aguila* featured the songs and dances of Mexico adapted to a melodrama. Sponsored by the House of Neighborly Service, the play was produced annually for several years during the 1930s and featured a cast drawn from the Mexican colonia.

GOOD FOR ONE ADMISSION TO

EL AGUILA

A MUSICAL DRAMA OF OLD MEXICO
Written by Bruce McDaniel
Directed by Webster Hall

House of Neighborly Service

Out-of-door theatre
Lawton Avenue, Redlands, Cal.

Sept. 9 and 10, 1932 No Seats Reserved
ADULT TICKET: 35 cents

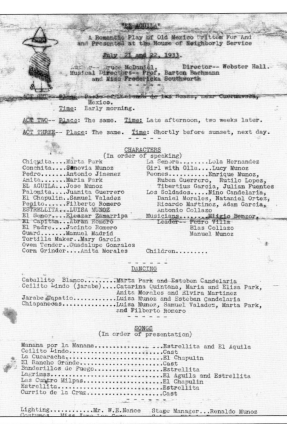

"EL AGUILA"

A Romantic Play of Old Mexico Written For And
and Presented at the House of Neighborly Service

July 21 and 22, 1933.

Author-- Bruce McDaniel. Director-- Webster Hall.
Musical Directors-- Prof. Barton Bachmann
and Miss Fredericka Southworth

ACT ONE-- Place: Parque Alamada de las Rosas, near Cuernavaca,
Mexico.
. Time: Early morning.

ACT TWO-- Place: The same. Time: Late afternoon, two weeks later.

ACT THREE-- Place: The same. Time: Shortly before sunset, next day.
- - - - -

CHARACTERS
(In order of speaking)

Chiquita....Marta Park La Senora.......Lola Hernandez
Conchita..Senovia Munoz Girl with Olla...Lucy Munoz
Pedro.......Antonio Jimenez Peones.........Enrique Munoz,
Anita.......Maria Park Ruben Guerrero, Rutilo Lopez,
EL AGUILA...Jose Munoz Tibertius Garcia, Julian Fuentes
Palomita....Juanita Guerrero Los Soldados.....Nino Candelaria,
El Chapulin..Samuel Valadez Daniel Morales, Nataniel Ortez,
Pepito......Filberto Romero Ricardo Martinez, Adam Garcia,
ESTRELLITA...LUISA MUNOZ Antonio Collazo
El Senor....Eleazar Zamarripa Musicians.......Eligio Benzor,
El Capitan...Abran Romero Leader-- Pedro Villa
El Padre....Jacinto Romero Blas Collazo
Guard.......Manuel Madrid Manuel Munoz
Tortilla Maker..Mary Garcia
Oven Tender..Guadalupe Gonzales
Corn Grinder....Anita Morales Children.........
- - - - -

DANCING

Caballito Blanco........Marta Park and Esteban Candelaria
Ceilito Lindo (jarabe)....Catarina Quintana, Maria and Elisa Park,
 Anita Morales and Elvira Martinez
Jarabe Tapatio..........Luisa Munoz and Esteban Candelaria
Chiapanecas.............Luisa Munoz, Samuel Valadez, Marta Park,
 and Filberto Romero
- - - - -

SONGS
(In order of presentation)

Manana por la Manana..............Estrellita and El Aguila
La Cucaracha......................Cast
Ceilito Lindo.....................El Chapulin
El Rancho Grande..................Cast
Banderillos de Fuego..............Estrellita
Lagrimas..........................El Aguila and Estrellita
Las Cuatro Milpas.................El Chapulin
Estrellita........................Estrellita
Currito de la Cruz................Cast
- - - - -

Lighting.....Mr. W.E.Nance Stage Manager...Renaldo Munoz
Costumes Miss Jane Lee Cave

This is the program and an opening-scene photograph of *El Aguila*, presented on the grounds of the House of Neighborly Service in July 1933. Largely forgotten, the play featured a cast and crew of over 30 people that performed for two nights to outstanding reviews and enthusiastic audiences. The original cast included several elders who participated in the Redlands Oral History Project, including Blas Coyazo.

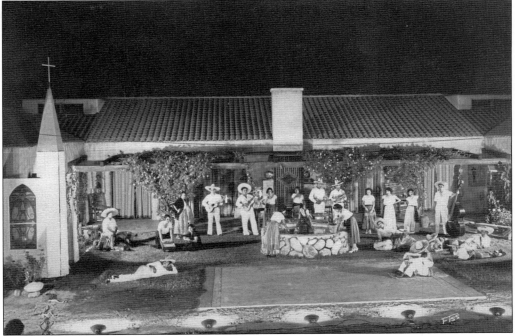

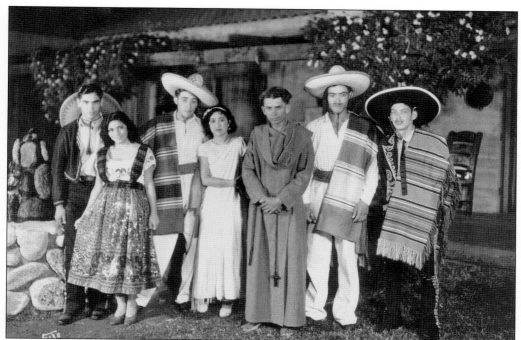

The El Aguila dancers, including Margarita Park, center in white, and Esteban Candelaria, far right in black, are pictured above with Jacinto Romero as El Padre. Jose Munoz, pictured right, played the lead role of El Aguila.

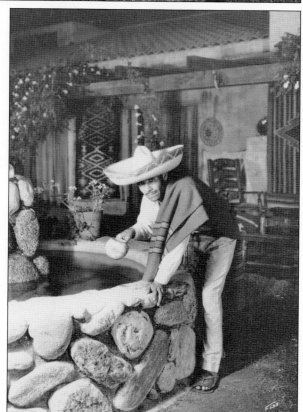

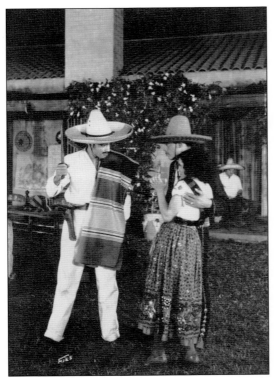

The cast drew from some of the top young singers, dancers, actors, and musicians in the area. A preview in the local paper noted that the play was "beautiful in every detail and one of the most attractive presentations offered this season." The glowing review concluded with the hope that "residents of the city who owe so much of their heritage to Mexico will do well to attend one of the two performances." It was further hoped that the play would become an annual tradition.

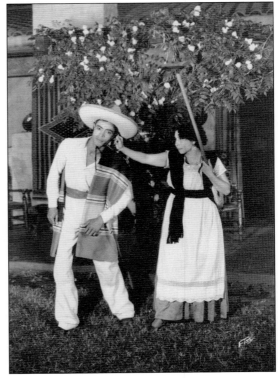

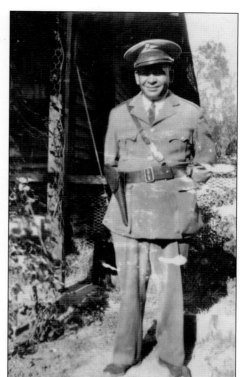

Cast as El Capitan, a brave suitor of the heroine of the play, Abe Romero is shown in costume at the family home on Ohio Street. Abe and his brother Jacinto Romero were both featured in the cast. In the photograph below, Abe is seen with his son Bob.

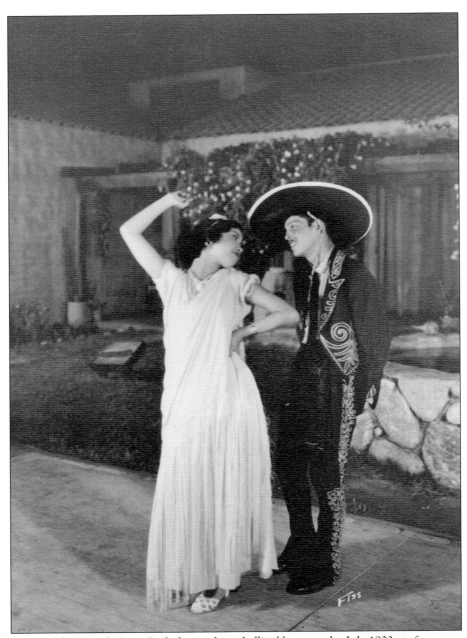

Esteban Candelaria and Marta Park dance the *caballito blanco* at the July 1933 performance of *El Aguila*. The play featured traditional dances, music, and costumes in a courtyard setting. By the time the play was produced, the House of Neighborly Service was fast becoming an institution on the Northside. Manasses "Chechi" Soto remarked: "The House of Neighborly Service was a stronghold in Redlands for many years, it was on the north side of town. Nowadays it's the south part of town, it's on the other side of the freeway. But that's where we used to go get involved, it was through the Presbyterian Church. We used to have softball games, basketball games, and things with the youth of our community, mostly Spanish-speaking kids or Anglos that happened to live in the neighborhood."

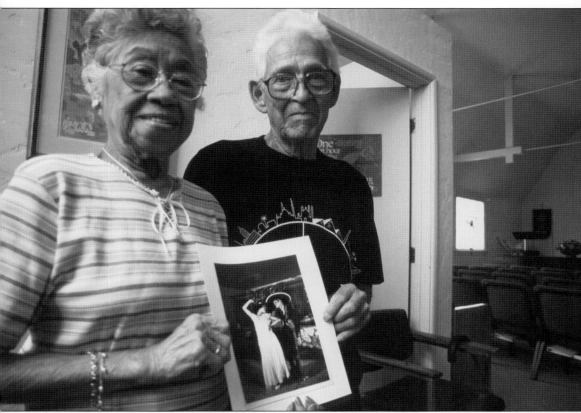

Steve Candelaria and Margaret Park Romero reunited at an Inland Mexican Heritage event 70 years later. Although living in the same town, the dancers had not seen one another since performing in the 1930s. Besides producing *El Aguila*, the House of Neighborly Service provided vital services to the community. Lupe Yglesias recalled, "All of our younger kids would go in there with Mrs. Carey to summer school. They would have crafts, something to read, like activities for summer. It was great for the Mexican kids, because we didn't have nothing else. They were great. Other than that, the kids wouldn't have had anything to do." (Photograph by Will Chesser.)

El Club Dramatico Mexicano was organized in February 1934. The purpose is the study and production of plays that portray Mexican life, customs and traditions. Membership is open to Mexican residents of the community interested in any phase of the production of such plays. A board of directors has general supervision of the policies of the organization and renders decisions on questions pertaining to its welfare. The personel of the first board of directors is as follows:—

Miss Alice Collins........ Executive
Mr. Roy White............ Chairman
Mr. Jose Quiroz
Mr. Emilio Tapia.
Mrs. W. A. M'Donald
Miss Edith Hanson
Miss Elsie Wallace
Mrs. Irene Wight

Acknowledgments:—
Assistant Director..... Mr. Elias Baca
Costumes................ Mr. Marcelino Silva
Stage Construction...... Mr. Melgoza
Music...Mr. Preciado, Mr. Chavez, Mrs. Reyes
Properties... House of Neighborly Service, Redlands
Program Design Mr. Marcelino Silva
Lumber... Victoria Avenue Citrus Association and Riverside City Schools

EL CLUB DRAMATICO MEXICANO
presents
THE MEXICAN PLAYERS
in
"EL AGUILA"
a musical drama in two acts
by
Bruce McDaniel
Herbert H. Humphreys — Director
May 10, 11 - 1934

By 1934, El Club Dramatico Mexicano was established to "study and produce plays that portray Mexican life, customs, and traditions." It was hoped that the club would provide a model for other such groups across the southland. By its second season, a complete overhaul of the original cast and traveling dates to Beaumont and Banning were among the changes that would eventually hamper the growth of the company. By the late 1930s, the club and the pageant had disappeared, to be preserved only in these photographs. For decades, the House of Neighborly Service worked to provide cultural enrichment to north Redlands. Though cut off from its core constituency by an elevated six-lane highway after the construction of I-10 freeway, the House of Neighborly Service continued its mission and left behind fond memories with the people who used it most.

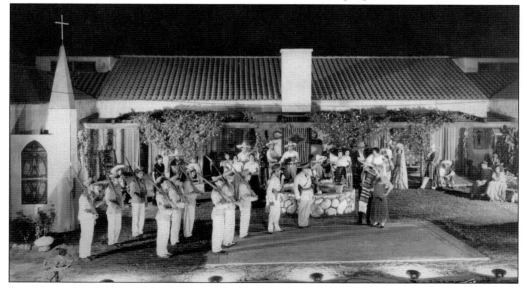

Four

TIMELINES

In the past, Mexican American heritage in California has been often ignored by the larger community in favor of an easily digestible Spanish Mission mythology that even continues to color the way some people of Mexican descent view themselves. Over the last 20 years, Mexican American elders from Redlands and the surrounding area have told their stories and given life to a new vision of our common past. In this excerpt, Angelina Cosme, Margaret Castro, and the author reflect on the need to reclaim, preserve, and pass on their heritage and culture with each new generation.

Gonzalez: "I've been doing this for some time now and people often ask me, 'Well, are you making money off of it, how do you live doing this?' But, you know, I really enjoy doing what I do. I like to sit down and talk to people. I like looking at these things. I think it's important. It's important for your grandkids and your great-grandkids to know this stuff is here."

Castro: "You know what that girl said, the one that spoke at that meeting? She said, 'If you don't do something, it's gonna die.' She said we have to keep alive what went down in those years, and that is so true."

Cosme: "You know, people like us, of our generation, are losing the 'Mexicanness' in us. We're losing it. And if we've lost it, if we have wandered away from the main trail, I wonder what's going to happen to our children and our grandchildren. That's a sad thing to contemplate, to think about."

Gonzalez: "That's why it's so important for people like yourselves to contribute to this. I want to thank you because so few people realize and think about what you're telling me right now. And if they do think it, they don't do something about it. That's where we're at, is trying to preserve some pieces of that past . . . because we don't want to lose it. If we don't keep it together, no one else is going to do it for us."

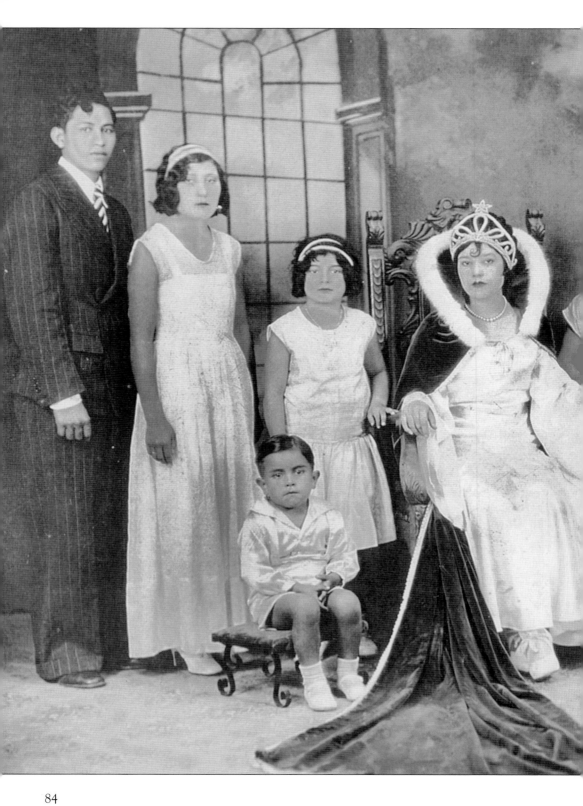

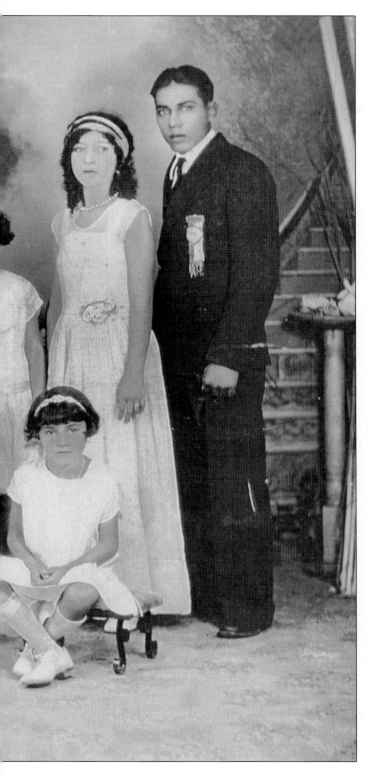

Pictured here in 1929 are the Dieciseis de Septiembre queen and her court. September 16, or Mexican Independence Day, was a major event on the social calendar of barrios across Southern California. Queen Lucy Hernandez and her court, consisting of Encarnacion "Chon" Manzano (left), Mary Macias (second from left), Josefina Lara (second from right), and Nick Manzano (right), reigned over a daylong fiesta complete with a parade, music, and dancing. Over the years, Cinco de Mayo celebrations eclipsed the Dieciseis fiestas. As a cultural touchstone, Cinco de Mayo, like other ethnic holidays, devolved into a commercialized shadow of its former self. But at the grassroots level, as people gain a new appreciation for the recent past and seek their own histories, local fiestas celebrating Dieciseis, Dias de Los Muertos, and other holidays of Mexican origin have completed the circle by celebrating with pride, dignity, and honor the community's culture and past and those ancestors whose ideals help shape its future. (Courtesy Margaret R. Castro.)

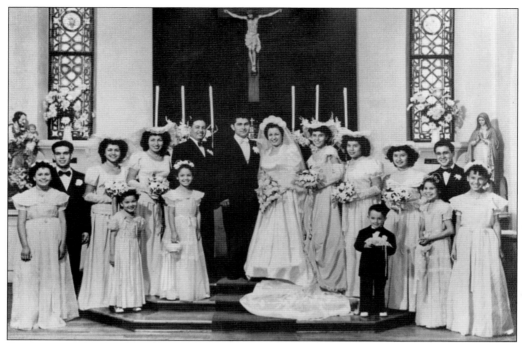

For most people of faith, lives begin and end in a church. While there were Protestant churches that served the Northside throughout its history, by and large, the Mexican population was Catholic. In the early days, Our Lady of Mercy served as a spiritual home to the growing colonia, but by the 1930s, it became apparent that the congregation needed a new space. Funds were raised one dollar at a time by donations collected by volunteers. St. Mary's Church opened its doors in 1943. Project participants Joe and Irene Gonzales were wed in the chapel in 1947. They are still married after more than 60 years. (Above, courtesy Joe Gonzales Jr.)

The Roques were among the founding families of St. Mary's Church. Angelina Sumaya is shown before her first communion in the 1940s. In the bottom photograph, family matriarch Dorotea Roque is pictured with her granddaughters before their first communion in the 1960s. As Margaret Castro describes below, religion and religious holidays were also important at home: "I'd like to remember my mama the way she was at Christmas, how she went all out. We had posadas, oh that is so strong in my mind, the posadas . . . Every Christmas we had posadas, nine days. It was so exciting to me. They had these big old mangers. A big part of the living room was taken up by it. They had mounds and little houses and lines and every day we'd go. And then we'd walk across the street and they would carry candles, you know? Like when Joseph and Mary were looking for a place to stay when Jesus was being born." (Both, courtesy Margaret R. Castro.)

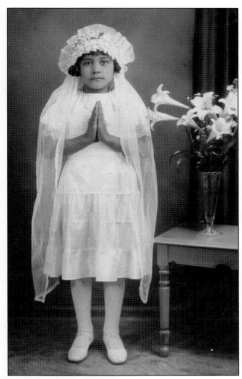

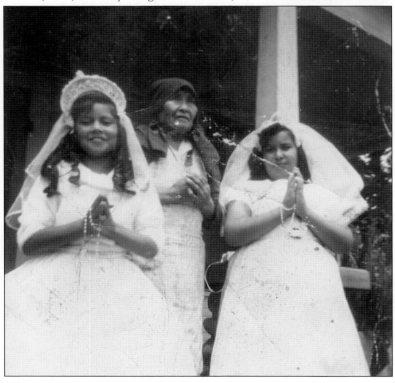

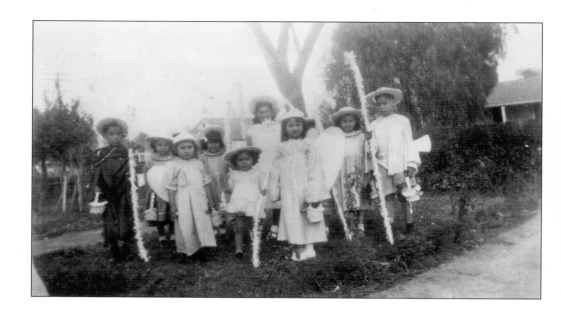

Margaret continued, "She'd be the one to pray, she'd be the one to lead the singing. We'd go across the street with the candles and be singing and the ones inside the house would be some of the ladies and they'd sing back, 'There is no place for you to stay,' in songs. So we'd walk back with our candles and we did this for nine days. I enjoyed that because they'd give us cookies; they'd give us hot chocolate. On December 24th everybody went to Mass, midnight Mass. We went with my mama, we'd walk and go to Mass. That stays still in my mind, how I enjoyed it." (Both, courtesy Margaret R. Castro.)

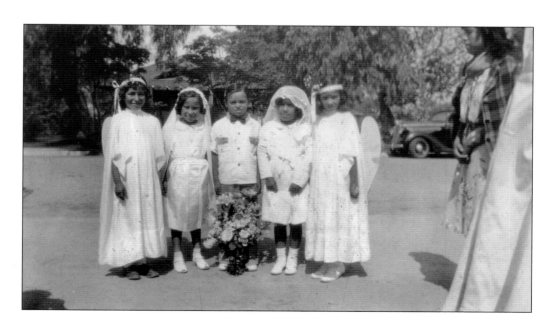

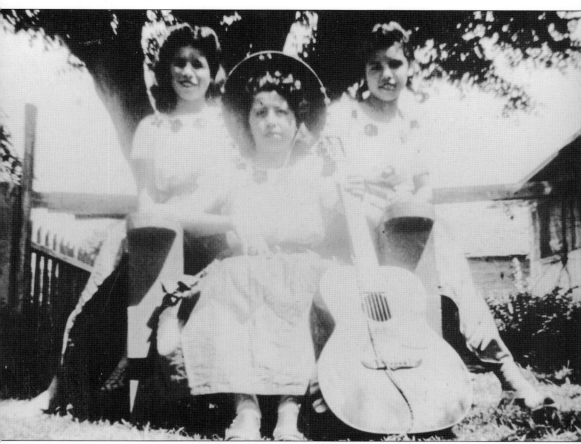

The St. Mary's Jamaica was an annual fundraising event that drew hundreds of people from the barrio. The fiestas were open to the public and included games, music, food, and a street dance. Pictured above, from left to right, are Rita Coyazo, Sally Coyazo, and Cecilia Coyazo posing before a performance at the 1943 Jamaica. (Courtesy Sam Coyazo Jr.)

At left, Jacinto Romero and his brother-in-law Jesus Chacon (wearing hat) arrive for services at Divine Savior Church on Union Avenue in the late 1930s. Below, Concepcion Chacon Romero leaves church with her brother Jesus in the late 1930s. Manasses Soto's father was a traveling pastor who ministered at the church. Soto recalled, "When I became involved in the Divine Savior Presbyterian Church in Redlands, as far as I know it was the only Spanish-speaking Presbyterian church in town. There's still some people going to our church, we must have about two or three, that still go. They were just kids when Divine Savior was brand new."

In the photograph at right, Jacinto and Concepcion Romero are pictured at Fairbanks Ranch in the early 1950s. Divine Savior Presbyterian Church founder Ramon Romero's sons (from left to right), Joe, Abe, and Ben, are pictured below in the 1960s. Soto recalled, "The church was Spanish-speaking all the way until 1968, when they decided that a lot of the youth were leaving because a lot of our youngsters were forgetting their Spanish. They couldn't understand it very well. So in order to change it, a lot of us could speak both languages and some of our parents could not, we decided to go to English-speaking."

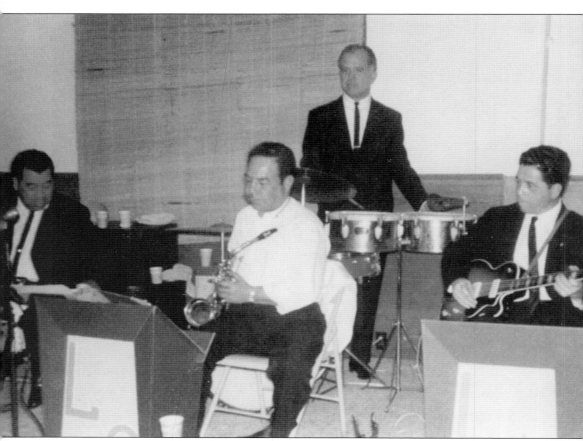

By the beginning of World War II, generations of Mexican American families had made Redlands their home. After the conflict and into the 1950s, the Mexican community was undergoing the same postwar adjustment as the rest of the country, including having more children and defining new roles and new directions for the future. At the conclusion of his service in World War II, Blas Coyazo, pictured here playing his guitar with the Lupe Sanchez Band in 1964, returned to increased competition for fewer jobs in citrus ranch work, as well as lower pay due to surplus manpower. Coyazo fell back on his musical talent and continued his prewar side job of playing in bands and orchestras. For over 50 years, Blas worked weekends playing all over Riverside and San Bernardino Counties. He recalled, "I first learned guitar back in the 1920s. But Eligio Benzor, he played violin and really got me started with bands. We used to play at *tardeadas* and anywhere else people wanted to hear us play." (Courtesy Blas Coyazo.)

Elodia "Lodi" Neri came from La Piedad, Michoacán, to Fontana in 1913. The following is an excerpt from her handwritten, unfinished autobiography: "My father started working for the Santa Fe railroad, so on November 10, 1918, we moved to San Bernardino. My father had found a big two-story house. He said the rent was very reasonable because the neighbors said it was haunted. . . . When we woke up the next day on November 11, 1918, we heard the Santa Fe whistle and train whistles. It was so noisy I couldn't stand it. My brother came home from downtown which was two blocks away and announced that the war was over. It was Armistice Day." (Both, courtesy Ida Walden.)

Before the 1960s, the Redlands barrio extended to Stuart Street near the railroad tracks. It included neighborhoods of small bungalow-style homes as well as large, two-story Craftsmen and Victorians along Pearl and Colton Avenues. Middle-class, working-class, and wealthy individuals lived along the quiet, tree-lined streets near The Terrace. From this mix of people came a vibrant community that began to extend its reach with each passing generation. This photograph shows Aurelio Placentia at home on High Street. (Courtesy Nellie Del Rio.)

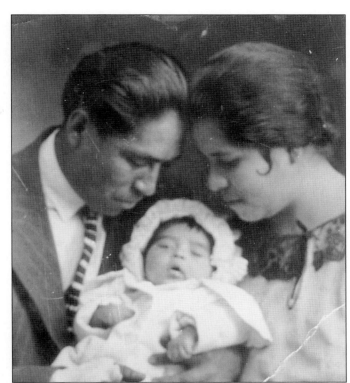

Nellie Hernandez is shown
with her parents (right)
and with her friend Aurelio
Placentia (below).

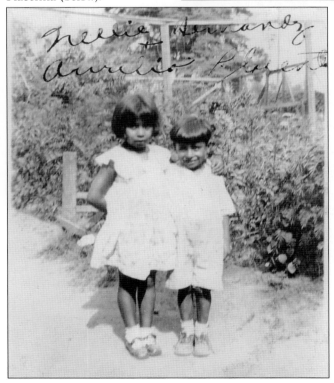

The image at left is a portrait postcard. Nellie Del Rio's cousin Chris Gallardo is pictured below on High Street in Redlands. (Both, courtesy Nellie Del Rio.)

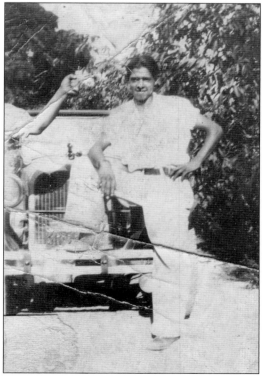

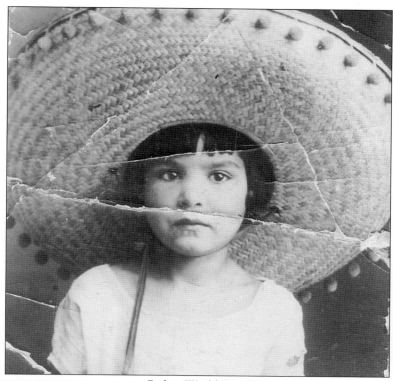

Before World War II, cameras were often a luxury for many working-class Mexican American families. Taken from the early 1900s through the 1950s, the images on pages 97 through 99 were part of a large scrapbook maintained by Consuela Coyazo and donated to Redlands Oral History Project in 1997 by her nephew Sam Coyazo Jr. Over 100 images, from candid scenes of everyday life in the barrio to penny arcade booth photographs to formal portraits, were preserved. (Both, courtesy Sam Coyazo Jr.)

The Coyazo image collection includes relatives, friends, and neighbors, many of who lived in the area around Calhoun and Columbia Streets. By the early 20th century, Mexican settler families were able to buy land and build homes away from the railroad tracks and bustle of downtown as the barrio expanded to meet the needs of a growing population. (Both, courtesy Sam Coyazo Jr.)

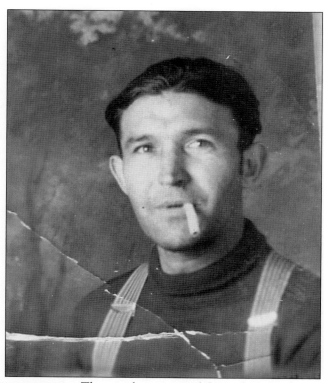

The people in some of these photographs appear throughout the collection but, in spite of efforts to put names to their faces, have never been identified. Preservation of images like these often falls to one relative in a family, and care must be taken to keep intact materials and gather as much information as possible from loved ones about photographic legacies such as these. (Both, courtesy Sam Coyazo Jr.)

The girl in the photograph above has never been identified. The IMH collection contains numerous studio images like this dating from the first half of the 20th century. Sam Coyazo Jr. is shown at right in front of his home on Calhoun Street in 1949. As a young man, Coyazo worked several citrus jobs, including hauling, loading, and smudging. "I learned to haul oranges with Art Carrie who was from Massachusetts and spoke with a real strong Eastern accent. He did not take to the hard work of hauling and lugging oranges, so he would pay me $1 to load his truck at the fields and another $1 to unload the oranges at the packing house. I was about 15 years old and I made $8 a day in 1947, which was pretty good money for me." (Both, courtesy Sam Coyazo Jr.)

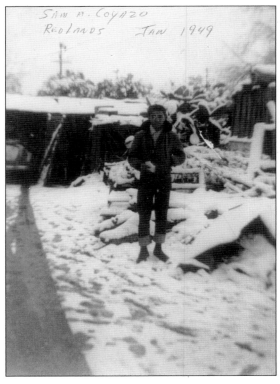

SAM M. COYAZO
REDLANDS JAN 1949

At right, Nellie Hernandez (standing left) and friends are pictured on Third Street in the late 1920s. Two Roque boys are dressed for Easter in the 1940s below. Lupe Roque Yglesias remembers "always having a camera around, always taking pictures." Many of the informal photographs of the Roques in this book were taken by Lupe. (Right, courtesy Nellie Del Rio; below, courtesy Margaret R. Castro.)

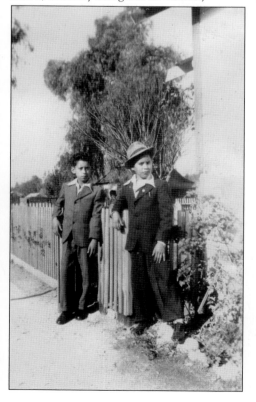

At left are the two Lupes—Lupe Yglesias (left) and Lupe Corrales—in Redlands in the late 1940s. The Roque family is in front of the Lincoln Shrine Museum in Redlands below. (Both, courtesy Margaret R. Castro.)

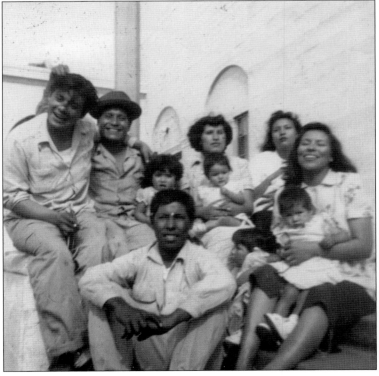

Margaret Castro's husband Trinidad, in the center, poses with his nephews Manuel (left) and Beto (right). Margaret recalled that: "He picked oranges for five years and then we started having our children, our daughters, then he worked for the Portland Cement for five years but he always got laid off every year for a couple of months. So then he started working for the City of Redlands. He drove a disposal truck until he got sick and they retired him. He had a heart condition, but all this time, even when he was sick, he went to work sick because he knew he had to bring the money for the family, which he always did." By 1955, A third generation of Roque children, Ronald, Felix, Nela, Vicki, and Robert (from left to right below) would see the barriers of legal segregation begin to fall. (Both, courtesy Margaret R. Castro.)

Above, children play in a Redlands park in the 1960s. Below, Armando Gonzales steps up to the plate at Community Park in the early 1970s. Though segregated public facilities and legal racism seem like distant memories, these stains on the American soul have not been fully cleansed. Carl Sepulveda remembers the difficulties encountered starting the first integrated baseball teams in Redlands during the 1950s: "It was rough going because the city wouldn't cooperate at all. The schools were against us, the Church was against us, so we had to go it alone more or less. But the kids from the south side of town mixed with the kids from the north side of town as a unit, and I'll tell you, they played together and they didn't care. They wanted to win." (Above, courtesy Margaret R. Castro.)

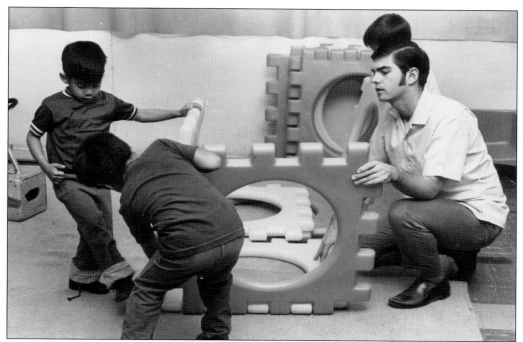

From left to right above, Carlos Ojeda, Bobby Gonzales, and an unidentified University of Redlands student work together at Redlands' first Head Start preschool in 1968. Manasses Soto, pictured at right below at a Cinco de Mayo event, observed, "We must continue to teach our youth to go to school, to get involved in their community, register and vote, and read between the lines, be sure that you're told by our leaders what they really think and not say something on one side of the mouth and something on the other side of the mouth, because a lot of people catch on to that, especially our youth."

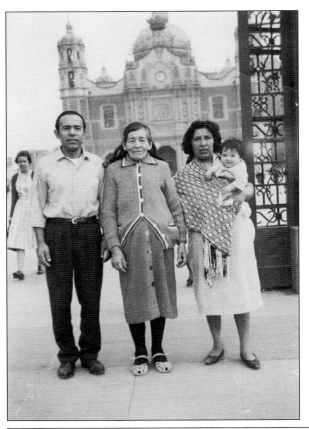

In the early 1940s, women entered the US workforce in unprecedented numbers. As young men went to war and a shortage of agricultural labor was predicted, the Bracero Program was established to fill the need for jobs formerly held by local workers. While this sometimes created tensions between the Braceros, known as *Los Renganchavos*, and local Mexican populations, many of the men who came as guest workers stayed, married, and continued the settlement patterns of earlier generations. Former Bracero Rafael Gonzalez is shown with his mother and sister in 1963 as he visits family in Mexico City. Rafael Gonzalez earned the certificate of achievement below from a citizenship class in 1960.

Redlands Evening High School
Redlands, California

Certificate of Achievement

awarded to ___Ralph Gonzales___ for the satisfactory completion of the course

in ___Citizenship___

consisting of ___37.5___ clock hours.

Mildred Stevens
INSTRUCTOR

Jack Brinkley
PRINCIPAL

May 1960
DATE

Rafael Gonzalez apprenticed as a shoemaker in Mexico before coming to the United States as a Bracero in 1942. Gonzalez dreamed of returning home and establishing a business but was delayed during the war and was among a group of Braceros stranded in San Bernardino without a contract or transportation home. Later, Gonzalez met Eunice Romero while working for her father, Jacinto Romero, at Fairbanks Ranch. Their second daughter, Melida, is shown with her dad in the early 1950s at right. Her daughter Bianca is shown with Eunice and Rafael Gonzalez at their home on Ohio Street in the 1970s. Gonzalez worked as a gardener and factory laborer but spent nearly 50 years as a *piscadero* in groves all over San Bernardino and Riverside Counties. "Rafa," as he was known to friends, worked the groves until shortly before his death at age 69.

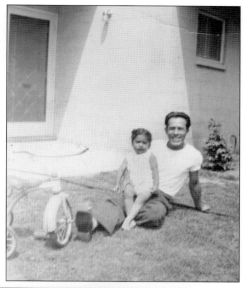

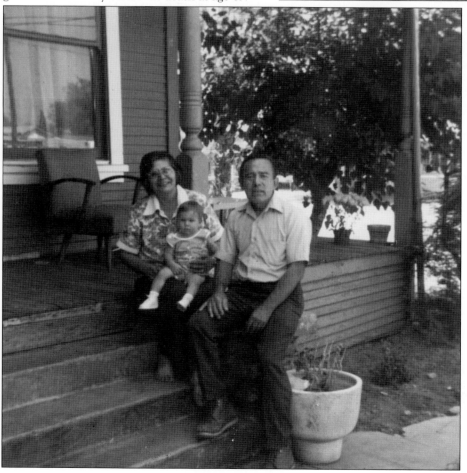

As a youth, Manuel "Manny" Villegas, shown with his wife, Eva Romero, was an Olympic hopeful in weight lifting and an honored educator and community advocate known throughout the Inland Empire. In a letter to the *Redlands Daily Facts*, the Sunday Concern Group, also known as the Menudo Club, a civil rights coordinating committee based at Impact Presbyterian Church, celebrated Villegas. It invited the public to a testimonial breakfast to honor him for "bringing athletic and cultural programs to area youth, and area youth to the programs, which included weight-lifting, Folklorico dancing, Scouting, and the first Spanish Club at Redlands High School." In addition to being a "tireless worker in the community," the letter noted that Villegas "taught English language classes to wartime braceros and Prisoners of War, as well as Spanish and Citizenship classes in Adult Education." (Below, courtesy Ernest Medina.)

SUNDAY CONCERNED GROUP

P.O. BOX 38 • REDLANDS, CALIFORNIA 92373

L.U.L.A.C.
AMER.-INDIAN CONSORTIUM
AMER.-CUBANS' CONSORTIUM
FRENCH-AMER. CITIZENS' COMM.

June 30, 1981

Editor
Redlands Daily Facts
Redlands CA 92373

The Sunday Concerned Group will serve a special breakfast complete with ceremonies, entertainment, and testimonials of gratitude and appreciation in honor of Mr. Manuel Villegas for his years of service and contributions to our youth, schools, and community on Sunday, July 12, 1981 from 9 to 11 A. M. in the Redlands Community Center, Washington & Lugenia Streets.

"Manny" Villegas came to Redlands from Zacatecas, Mexico, via El Paso, Texas and Cucamonga, California, where he was educated. He received his B. A. degree in 1933, and his M. A. degree in 1957 from the University of Redlands.

Throughout his professional life he was a teacher, and a tireless worker in the community, from Fontana, to Cucamonga, and since 1952 in Redlands. He devoted his efforts to bringing athletic and cultural programs to area youth, and area youth to the programs, which included weight lifting, Folklorico dancing, Scouting, and the first Spanish Club in Redlands High School. He taught English language classes to wartime Braceros and Prisoners of War, as well as Spanish and Citizenship classes in Adult Education.

After his retirement from Redlands High School, he became Senior Information & Referral Services Coordinator until illness limited his activities.

Villegas and his wife are pictured with
their nephew Donald Montgomery, a
sailor during World War II. Both men
graduated from the University of Redlands
and taught in Redlands schools.

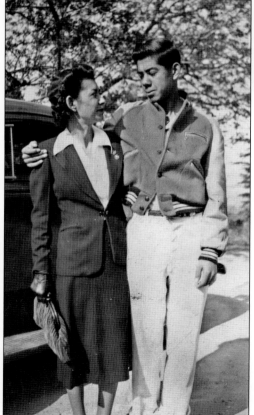

Simona "Sammy" Castillo was born in East Highland and spent most of her career at St. Bernardine's Hospital as a surgical registered nurse. Castillo spoke of her experiences, "I graduated Redlands High School in 1939. And from there, I went on, I got me four scholarships. I made it through the University of Redlands. I finished my four years, and then from there I went two years to Valley College to finish my nursing career. I made it. Oh, I tell you. I had 42 years of nursing, and that was beautiful. To me, it was just like a month, working a month. That's how much I was in love with my job. I liked my job so well that it was kind of hard to give it up." (Courtesy Sam Coyazo Jr.)

This letter from the Sunday Concerned Group offers congratulations to Oddie Martinez on his election to Redlands City Council. Martinez later became mayor of Redlands. (Courtesy Ernest Medina.)

Eunice Romero Gonzales is pictured at right as a child at Fairbanks Ranch. Below, Gonzales receives a degree from the University of La Verne in 1978. After raising a family, working as a laborer, and serving as a classroom aide in Redlands schools, Gonzales returned to college and earned a teaching credential. Years after retiring from the San Bernardino Unified School District, she recalled, "I didn't graduate from high school and well, I was like about 50 years old when a program was started through La Verne Colleges for bilingual educators, and I was lucky enough to know both languages fluently. So, I was able to participate in the program, which was—the acronym was SABER—and then I finished my college and I went into teaching."

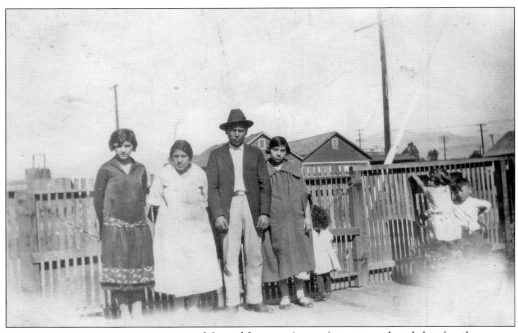

REDLANDS
ORAL HISTORY
PROJECT

PROUDLY
PRESENTS:

VISIONS & VERSIONS

LIVING LIVES IN THE
EAST VALLEY

APRIL 29TH
THROUGH
JUNE 17TH
2000
A.K. SMILEY PUBLIC LIBRARY
REDLANDS, CALIFORNIA

Manuel Jacques (center) is pictured with his family at home in Redlands in the 1920s. This image was among the many collected for the Visions and Versions Exhibition. Sponsored by A.K. Smiley Public Library and the California Council for the Humanities, Visions and Versions opened in April 2000. The main exhibit included storyboards, original photographs and documents, picking equipment, family Bibles, and other memorabilia from six years of Redlands Oral History Project research. The show sparked interest in continuing and expanding the collection outside of Redlands. (Above, courtesy Mary Garcia.)

The Visions and Versions exhibit, on display at Smiley Library in May 2000, shows picking equipment and a Mexican migration map, designed by mapmaker Sean Redar.

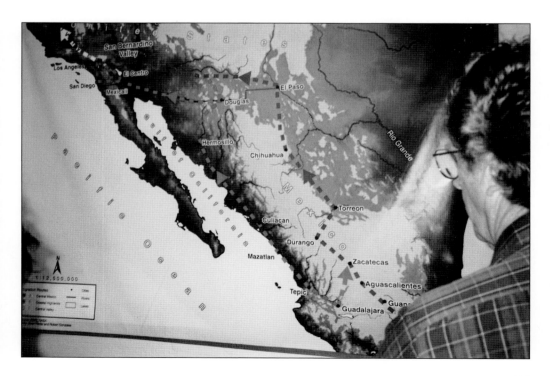

After the conclusion of Visions and Versions, lingering questions remained concerning the construction of the Interstate 10 freeway and the changes to neighborhoods along its proposed route. Leland and Mae Lubinsky's business and home on Highway 99 were in the path of freeway development. Their son Leland, pictured here, still lives on the remaining land, which has been in their family since the 1930s. In the photograph below, Concha Yglesias stands in front of her home on Pearl Avenue near what is now the Sixth Street freeway on-ramp. Many homes along Pearl Avenue, such as those depicted in this image from the 1940s, were destroyed to create the new road. The freeway changed more than just the geography of the town. (Above, photograph by Will Chesser; below, courtesy Margaret R. Castro.)

Long before the freeway came through town, Winn's Drug Store was a fixture in the neighborhood. From its beginnings in the 1930s, the store had a soda fountain and grill that attracted people from all over for its pie, milk shakes, and local gossip. By the time this picture was taken, the freeway had created a permanent barrier between the north and south sides and made the imaginary line separating the town all too concrete and real. By the late 1990s, Winn's was gone, a victim of chain pharmacy expansion, and was replaced by a liquor store and donut shop. Pictured below, the town is broken and divided by the freeway, a monumental architectural wonder of the mid-20th century. (Below, photograph by Juliet Conlon.)

Inland Mexican Heritage was founded in 2001 to continue developing materials from the Redlands Oral History Project. In 2002, IMH was awarded a grant by the California Council for the Humanities to produce *Living on the Dime: a View of the World From Along I-10*. This three-year initiative would go on to document over 100 hours of stories on video and archive several thousand images taken in communities along the Interstate corridor from Bloomington to Blythe. In the photograph below, project participants Lupe Yglesias Roque and Armando Lopez look at a display during a *Living on the Dime* event in 2004.

Mexican circus performers and mariachis depict long traditions of both music and performance in Mexican communities across the Southwest. (Both photographs by Will Chesser.)

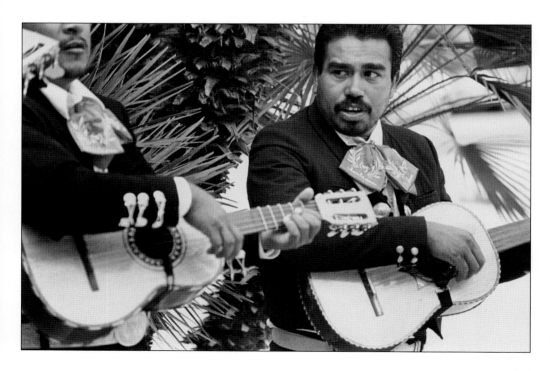

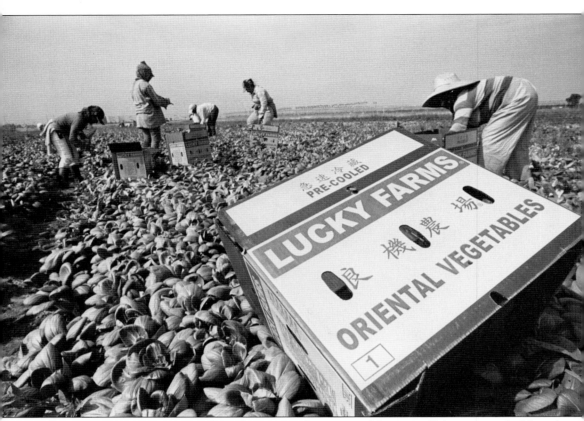

For over a century, migrant work has been a significant part of the story of Mexicans in the United States. This image of Lucky Farms in Loma Linda shows how little has changed for the average Mexican immigrant. The farm, located on the former Fairbanks Citrus Ranch, now grows Chinese vegetables for the global market. Since the 1990s, farm laborers bore witness to distribution centers, a variety of businesses, and a water park rising from the surrounding soil, providing little opportunity and paving over the last remnants of the valley's storied agricultural past.

In 2005, Inland Mexican Heritage hosted a History for Breakfast program in Redlands that drew many past project participants. Angelina Cosme (right) and Margaret Castro (left) are pictured above. Lupe Yglesias is pictured below. (Both photographs by Will Chesser.)

Steve Candelaria and his son attended the History for Breakfast program, curious to see what it was all about. To their surprise, Candelaria was reunited with Martha Park Romero, his former dance partner, whom he had not seen in nearly 70 years. (Photograph by Will Chesser.)

Martha Park Romero, age 90, enjoys renewing old ties and reliving local history with friends and family at History for Breakfast. (Photograph by Will Chesser.)

Joe and Irene Gonzales are still active in the community. (Photograph by Will Chesser.)

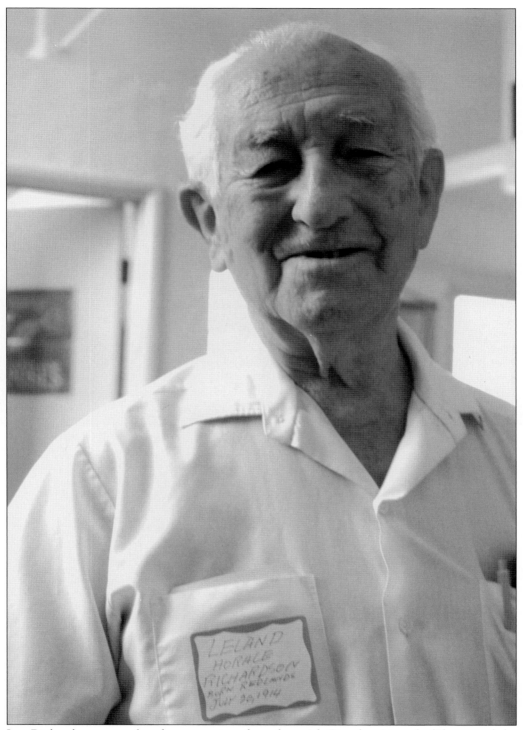

Lee Richardson spent decades as an aircraft worker with Douglas Aircraft. (Photograph by Will Chesser.)

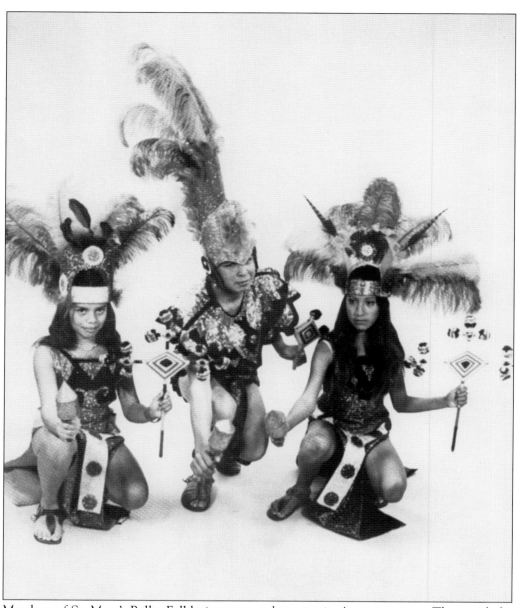

Members of St. Mary's Ballet Folklorico pose as *danzantes* in Aztec costumes. The search for identity and connections to the past in Mexican American communities has been long and taken many forms. To many, history is a mere recitation of dates and facts. To others, it is buildings, monuments, and the brick and mortar they are made from. But to some, the past is more fluid—alive with sound, motion, and an energy all its own. Music and dance, including the traditions of *danza* (Aztec dance), ballet folklorico, mariachi, and *norteño*, are a vital part the Mexican American soul. Regardless of circumstances, these strong ties to the Mexican cultural experience have remained deep within the *corazon* of the barrios. While American culture has rewired many aspects of Mexican American lives, the desire for *Mexicanidad*—the knowledge of, respect for, and embracing of a Mexican-influenced culture and worldview—has not diminished. (Courtesy Dolores Cortez.)

For a generation of children in Redlands, St. Mary's Ballet Folklorico was the main representation and link to Mexican culture. The troupe was established by parents in 1974 and sought to "educate their children in their Hispanic culture and heritage." Under the direction of Redlands resident Delores Ramirez Cortez, the group grew and thrived. Cortez was interviewed for *Living on the Dime* shortly after the 30th anniversary of the group.

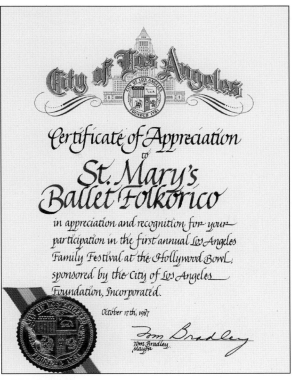

City of Los Angeles

Certificate of Appreciation
to
St. Mary's
Ballet Folkorico

in appreciation and recognition for your participation in the first annual *Los Angeles Family Festival at the Hollywood Bowl*, sponsored by the *City of Los Angeles Foundation, Incorporated.*

October 17th, 1987

Tom Bradley
Tom Bradley
Mayor

St. Mary's Ballet Folklorico
of Redlands
20th Anniversary
Performance

Come join us as we present the cultural music and dance of Mexico

Saturday, July 23, 1994
Matinee 2:00pm - Evening 6:00pm

Glenn Wallichs Theatre
Corner of University and Sylvan Blvd
(University of Redlands Campus)

For More Information Call:
Delores Cortez, Director
(909) 793-5002
Tickets $5.00 Adults - $3.00 Children/Seniors

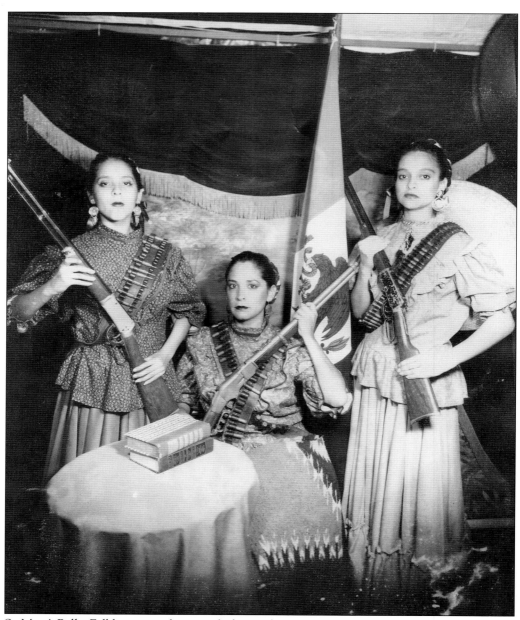

St. Mary's Ballet Folklorico members pose before performing a number from the Mexican Revolution. The troupe was later banned from performing at public schools while carrying prop weapons. Manasses Soto summed up the thoughts of many project participants when he stated: "I feel that since you're involved in this very interesting subject about, I'm not gonna say Spanish-speaking, I'm gonna say Mexican. Mexican American people in our community. I am interested in what you are doing because we have to find somebody in the community who can go back into the early 1900s, and no doubt there's somebody here that's still living that was young at that time, so we can get something written down to tell us who was here, what they did, and what they were involved with in those days. Not just, 'Well, we were here to pick oranges and do all the hard labor.'" (Courtesy Dolores Cortez.)

Bibliography

Principal sources for this volume are 50 Redlands Oral History Project audio and video interviews held by Inland Mexican Heritage and recorded between 1992 and 2005. Twenty-two interview transcripts are available at A.K. Smiley Public Library under the title *Citrus, Labor, and Community*. Many primary and secondary sources were consulted, but space limitations prevent us from listing them in their entirety. Thanks and respect to Hunter S. Thompson, Carey McWilliams, Kurt Vonnegut, Los Lobos, Victor Villasenor, Joan Didion, Spalding Grey, Ernesto Galarza, Oscar Z. Acosta, Alfredo Acosta Figueroa, Donald Worster, Frank Zappa, Adam Yauch, Vine Deloria Jr., and Lalo Guerrero for all their inspiration.

About the Organization

Inland Mexican Heritage (IMH) was established in 2001 to increase awareness of the stories and legacy of Mexican American, Mexican immigrant, and indigenous people of inland Southern California through historical research, preservation, and public presentation of cultural materials. Panchebek Films was created as an offshoot of IMH in 2006 to produce documentary video based on research conducted by Inland Mexican Heritage–supported projects. As of 2012, IMH and Panchebek have independently produced seven documentary films, several major exhibitions, and Mexican cultural fiestas for Cinco de Mayo, Dieciseis de Septiembre, and Dia de los Muertos. Founder Antonio Gonzalez Vasquez lectures frequently and provides multimedia presentations on Mexican American culture and heritage.

Discover Thousands of Local History Books Featuring Millions of Vintage Images

Arcadia Publishing, the leading local history publisher in the United States, is committed to making history accessible and meaningful through publishing books that celebrate and preserve the heritage of America's people and places.

Find more books like this at
www.arcadiapublishing.com

Search for your hometown history, your old stomping grounds, and even your favorite sports team.

Consistent with our mission to preserve history on a local level, this book was printed in South Carolina on American-made paper and manufactured entirely in the United States. Products carrying the accredited Forest Stewardship Council (FSC) label are printed on 100 percent FSC-certified paper.

MADE IN THE USA